Behold, a virgin shall be with child,
and shall bring forth a son,
and they shall call His name Immanuel . . .
God with us.

MATTHEW 1:23

IMMANUEL
GOD WITH US

THE LIFE OF CHRIST IN ART

Robert Doares

ARTIST

CROSSWAY BOOKS • WHEATON, ILLINOIS
A DIVISION OF GOOD NEWS PUBLISHERS

Immanuel, God With Us: The Life of Christ in Art

Copyright © 1994 by Robert Doares

Published by Crossway Books
 a division of Good News Publishers
 1300 Crescent Street
 Wheaton, Illinois 60187

Cover artwork: *The Call of the Four Fishermen,* Robert Doares

Art Direction/Design: Mark Schramm

First printing, 1995

Printed in the United States of America

Library of Congress Cataloging-in-Publication Data
Doares, Robert G.
 Immanuel, God with us : the life of Christ in art / Robert Doares.
 p. cm.
 1. Doares, Robert G. 2. Jesus Christ—Art. 3. Jesus Christ—
Biography. I. Title.
NC975.5.D6A4 1995 741.973—dc20 95-21921
ISBN 0-89107-792-8

03 02 01 00 99 98
15 14 13 12 11 10 9 8 7 6 5 4 3 2

To our Lord Jesus Christ
for all His love and tender mercies

Contents

Acknowledgments

My eternal gratitude to . . .

My precious and beloved Kay, who preferred that I devote my time to honor our Lord with my talent rather than to seek worldly success in fine art;

Jim Fleming, director of The Jerusalem Center for Biblical Studies, for his much-needed help;

Martha Ritmëyer, artist for The Israel Exploration Society, for her generous contribution of research material;

All those who created the resources and reference material which helped so much in making *Immanuel, God With Us* what it is;

The Waterworks Visual Arts Center in Salisbury, North Carolina, where the project was first invited for exhibit;

John Carter, who saw the exhibit and later brought Leighton Ford to view the series;

Leighton Ford, who recommended the project to the Billy Graham Center in Wheaton, Illinois;

James Kraakevik, Director of the Center, who introduced the project to the Graham Center Museum director;

James Stambaugh, Director of the Museum, who generously accepted it for an exhibit;

Lane Dennis, Crossway Books president, who saw the exhibit and expressed the desire to publish *Immanuel, God With Us* as a book;

Crossway's Leonard G. Goss, Editor-in-Chief, and Kris Bearss, for their work in editing and revising my original text for the book;

And the entire staff at Crossway Books who have done so much to make the book exceptional.

Robert Doares

Publisher's Foreword

THE FIFTY-FOUR DRAWINGS AND PAINTINGS reproduced in this volume comprise the entire collection of a most remarkable series. Created by artist Robert Doares over a period of nearly thirty years, the *Immanuel* work is a most extraordinary accomplishment.

Those who have seen the series on exhibit are often astonished by its magnitude. The intricate detail, the panoramic vistas, the depth of expression, the biblical reality are almost beyond comprehension. Certainly no one in modern times has undertaken to illustrate the Scriptures on this scale and with this level of technical expertise.

Here, in the creation of this volume, we have sought to make this experience available to the many thousands of readers who would otherwise be unable to see the *Immanuel* collection in person. At the same time,

publishing the collection in book form presents a formidable challenge, perhaps the most difficult being how to capture the panoramic perspective of the original 48" by 15" art within the pages of a book. The greatest care has been taken, therefore, in the production of this volume—to capture the intricate detail, the subtle play of light and shadow, the nuances of tone and color. As described in the NOTES ON PRODUCTION at the end, the creation of this volume brings together the finest efforts of skilled craftsmen and printing technology—from layout and design to photography, laser scanning, computer-enhanced imaging, printing, production, and book binding. The result is an art book of the highest quality which seeks to do justice to the brilliance of the art itself.

Remarkably, artist Robert Doares never intended the *Immanuel* series for public display or publication. Doares created the series purely as a personal expression of his faith and his desire to create works of art that would glorify God—never expecting that there would be any public interest in his work. Wherever the pieces have been shown, however, the response has been extraordinary.

Doares began the work in the 1960s as a group of paintings on the life of Christ which he hoped to complete sometime in the future. At that time, Doares was well-established in his career as a commercial artist. The project, however, was set aside as he continued his career and then entered the field of fine art in 1969, which included shows at The Coliseum in New York and the New Jersey Master's show at the Heritage Gallery.

By the late 1970s, however, Doares realized that fine art had become just as commercialized as the work of illustration, and he lost interest in the field. Since an artist must "produce art or perish," he was relieved when the idea for the life of Christ series resurfaced in his thinking. Because of his commitment to Christ, this undertaking put him on an entirely new and exciting path, and he picked up where he had left off nearly twenty years before.

Doares admits, "I always wanted to become an artist. So immediately following my high school graduation in 1929, I set out from Maxton, North Carolina, for New York City to begin my career."

With only $25 in his pocket, Doares took whatever odd jobs he could find while developing his talent in his spare time. It took ten years before he got his first big break with Wanamaker's Men's Store, where he convinced the store that some of their blank walls could be enhanced by murals.

With his career as a commercial artist just beginning, Doares studied at the Grand Central School of Art, taking courses briefly under Harvey Dunn, "dean" of American illustrators. Doares entered the military in 1941 classified as an artist, where his duties included mural painting, training aids and teaching art.

After the war Doares continued his career as a freelance illustrator, doing cover and story illustrations for such leading publications as *Outdoor Life*, Doubleday and Harpers. He has illustrated dozens of Christian books as well, including the beloved bestsellers *A Shepherd Looks at Psalm 23* by Phillip W. Keller (Zondervan) and *Devotions for the Children's Hour* by Kenneth N. Taylor (Moody).

One of the most striking features of Doares's work is his intricate attention to detail and historical accuracy. Doares notes that a wealth of archaeological material on the life and times of Christ has become available in recent decades. He has supplemented these findings with trips to the Library of Congress and to Israel, including numerous photographic excursions, contacts with archaeologists in the field, and research in Greek dictionaries and other sources. All of this has provided him the extensive background information he needed in order to approach each drawing from a historic and documentary, as well as a religious, point of view.

At the same time, Doares cautions that authorities in every field sometimes differ. Therefore, he has had to decide in some cases how best to use the research material. Whenever the available information conflicted with the biblical narrative, Doares notes, the Bible was the authority he followed. But since the Bible gives little detail about settings and locations, it was necessary to use imagination in the pictures and the text. "If people have a better idea than what I have drawn," Doares explains, "I urge the viewers to keep their own idea of the way they see the scene. My hope is that in the next life the Lord will let me do a new, completely accurate version!"

As the publisher of this extraordinary book, we share the vision and hope of Robert Doares—that God would indeed be glorified by His gift of creativity so beautifully expressed in the *Immanuel* collection, and that the book might be used by Him to help us understand more clearly the meaning of "Immanuel."

—LANE T. DENNIS, PH.D.
CROSSWAY BOOKS,
PRESIDENT

IMMANUEL
GOD WITH US
THE LIFE OF CHRIST IN ART

The Nativity

There is much historical evidence that Jesus was born in the cave in Bethlehem which is now located in the Church of the Nativity. Why do we believe that this is the place of Jesus' birth? Perhaps the most significant reason is that the Roman ruler Hadrian (A.D. 76–138)—in his attempt to discredit Christianity—desecrated the cave, along with all other locations associated with the life of Christ.

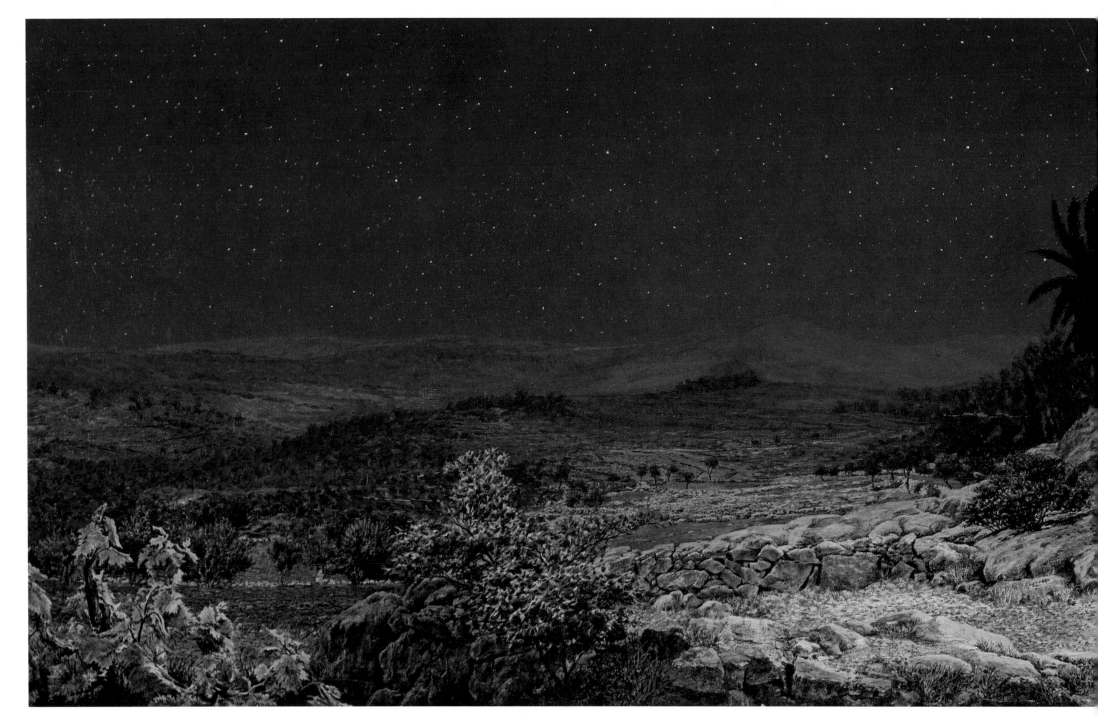

Although Hadrian turned the cave into a pagan shrine to the God of Adonis, the cave was later reclaimed for Christians by Constantine, who built the Church of the Nativity on the site in A.D. 330.

At a near distance in the far left of the scene below, the campfire of the shepherds can be seen.

Luke 2:1–7

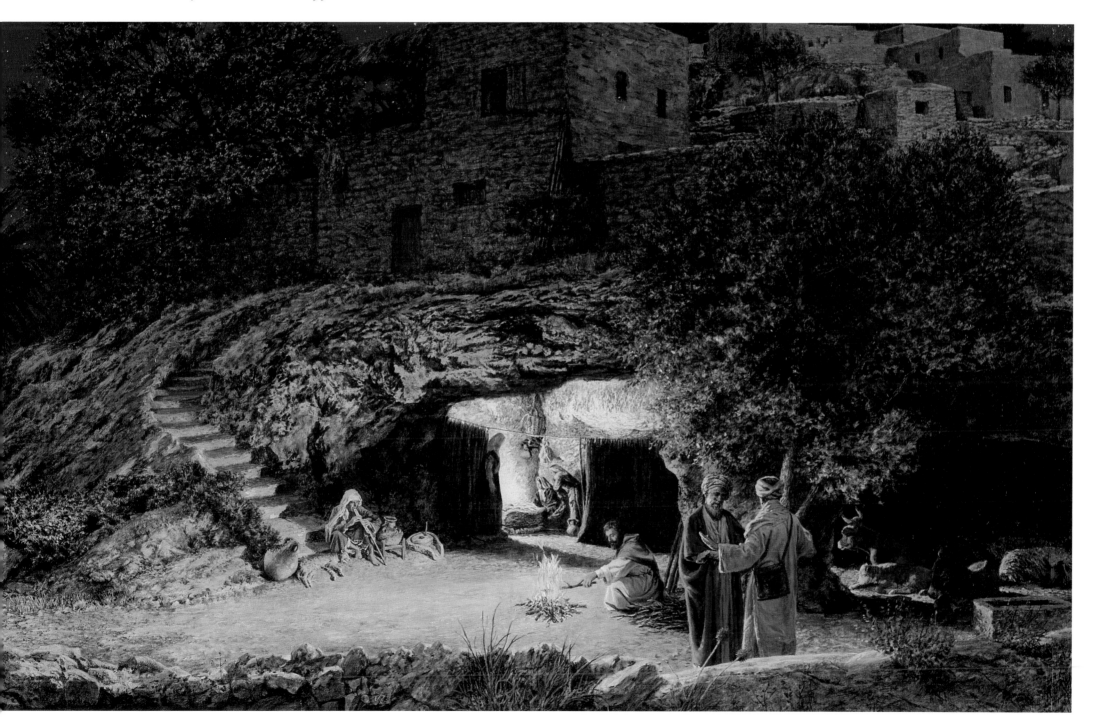

The Angelic Announcement

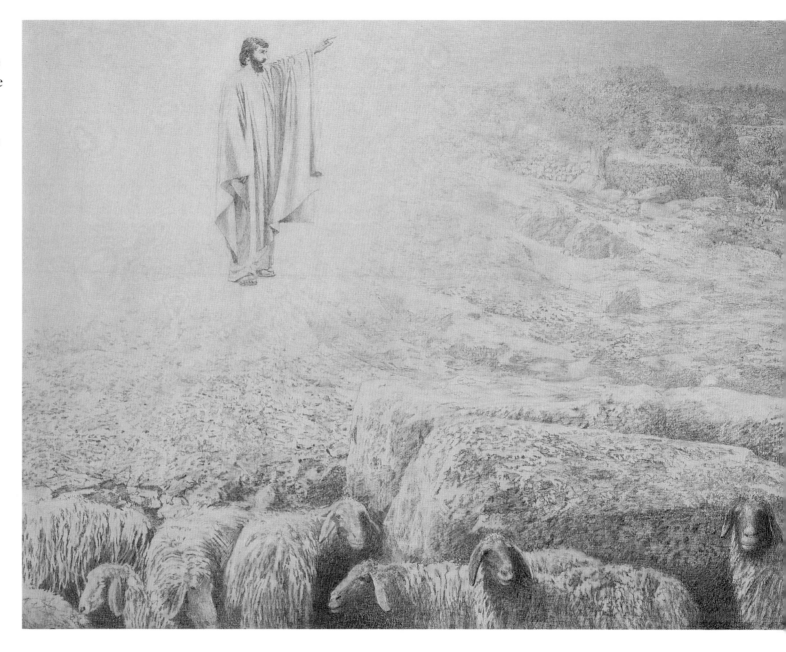

Since the night watch of the shepherds could have taken place in any one of many locations around Bethlehem, a gentle slope was selected about a half-mile away. From here the small village of Bethlehem could be seen in line with the cave opening. Archaeologists believe the cave was on the side of the hill facing the shepherds. In the scene above, the cave where Jesus was born is shown with the lamplight shining in it.

Suddenly, the angel of the Lord stood by them *"and the glory of the Lord shone around them, and they were terrified. But the angel said to them, 'Do not be afraid. I bring you good news of great joy that will be for all the people. Today in the town of David a Savior has been born to you; He is Christ the Lord.'"*

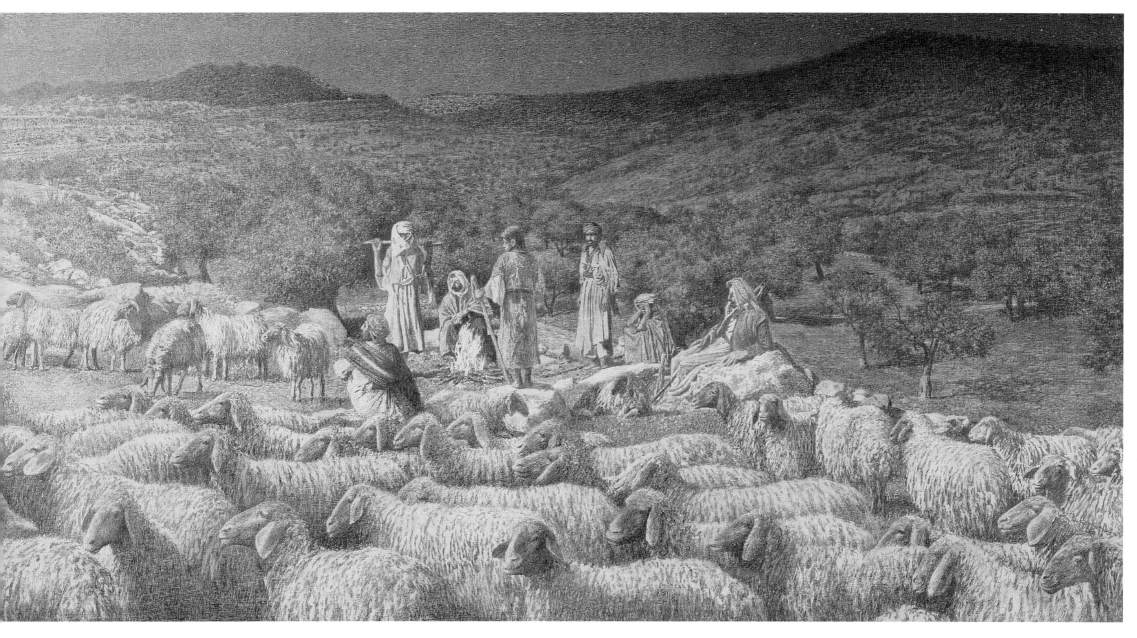

Luke 2:8–20

17

The Visit of the Magi

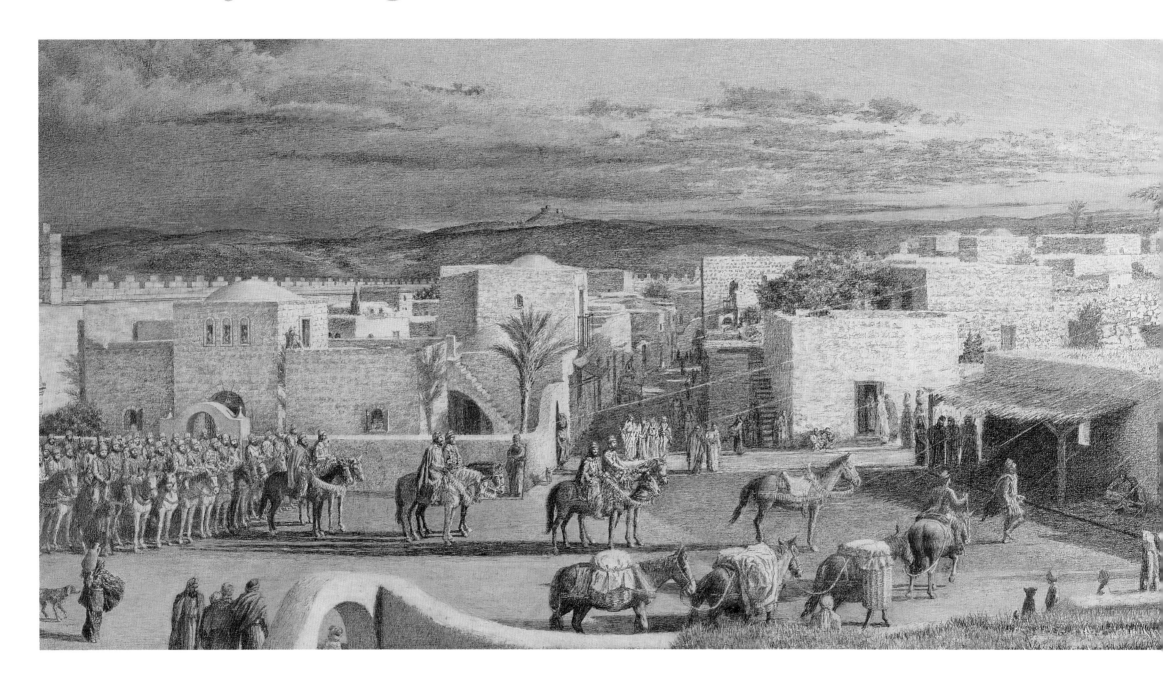

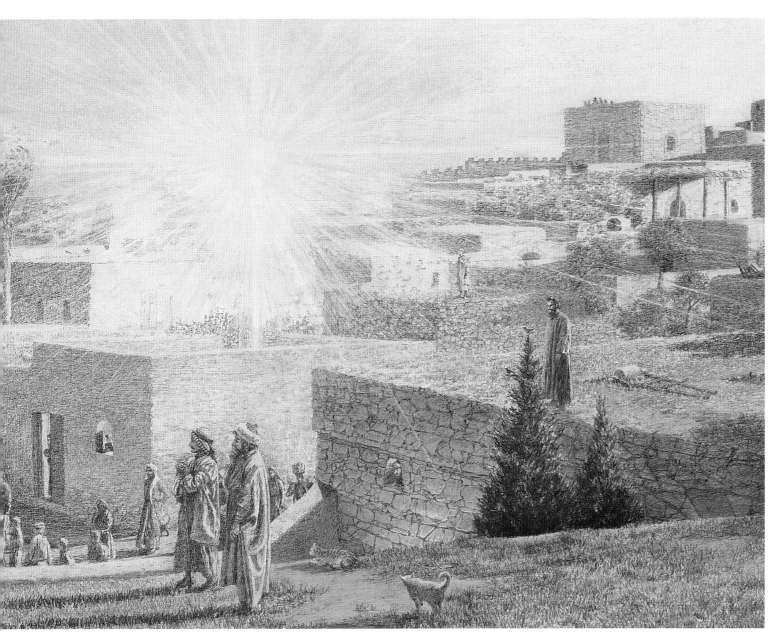

The Magi were members of a political aristocracy and priesthood representing the Parthian dynasty which ruled over territories of the former Persian Empire. This was the only kingdom the Romans could not conquer, and there was much Jewish influence in Parthia as well as a sizable Jewish population.

Parthia had helped the Hasmonean dynasty in Judea stay in power until the Romans took control and appointed Herod as king. Herod was captured by Parthian forces and barely escaped to Rome for reinforcements before he could begin to reign. So it was not surprising that he was troubled, and all Jerusalem with him, when these Parthian rulers—the Magi—came with an army to inquire about his successor.

The Magi must have expected the star to lead them directly to the royal palace. Where else would the King of the Jews be found? So when the star disappeared, they continued on to Jerusalem. Perhaps this was God's way of telling Herod that the Messiah had arrived.

When Herod sent them to the little town of Bethlehem, the Magi must have been somewhat confused and perhaps even disappointed. Even so, since that elusive star had made such a powerful impression upon them, they pressed on in their search. Their diligence was rewarded by the sudden reappearance of the star—and when they saw it *they were overjoyed!* It *"went ahead of them until it stopped over the place where the child was."*

Then they went into the house and saw the child with Mary His mother, and they fell down and worshipped Him. They offered Him gifts of gold, frankincense, and myrrh.

MATTHEW 2:1–12

The Temple Visit of the Boy Jesus

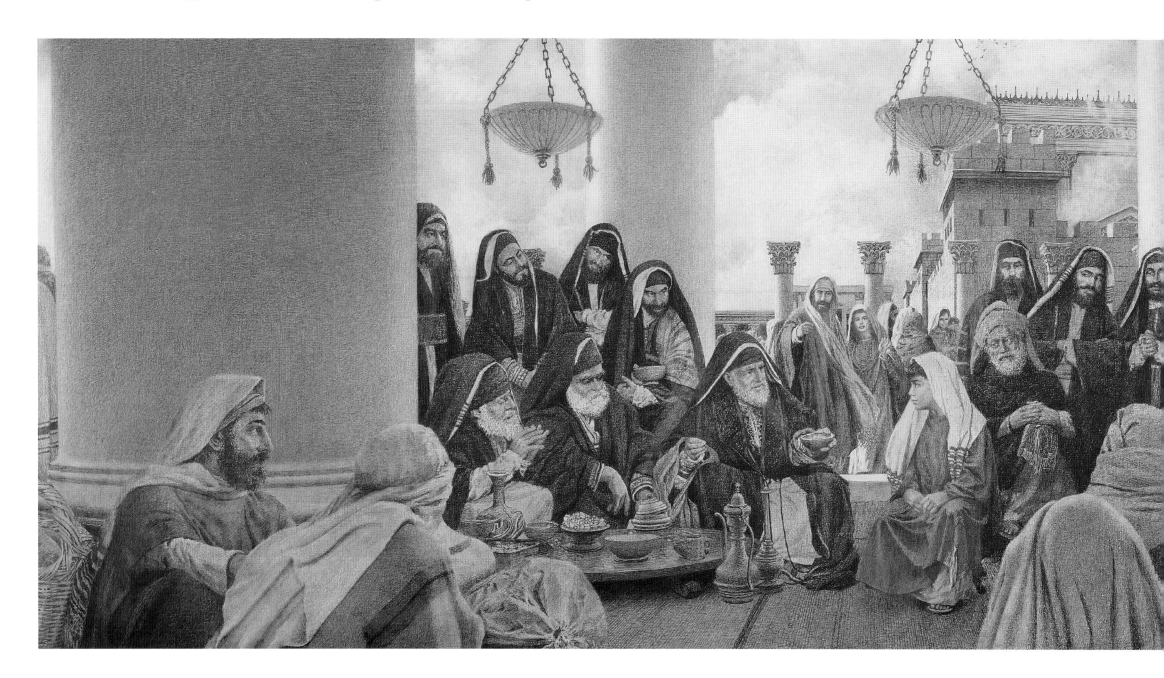

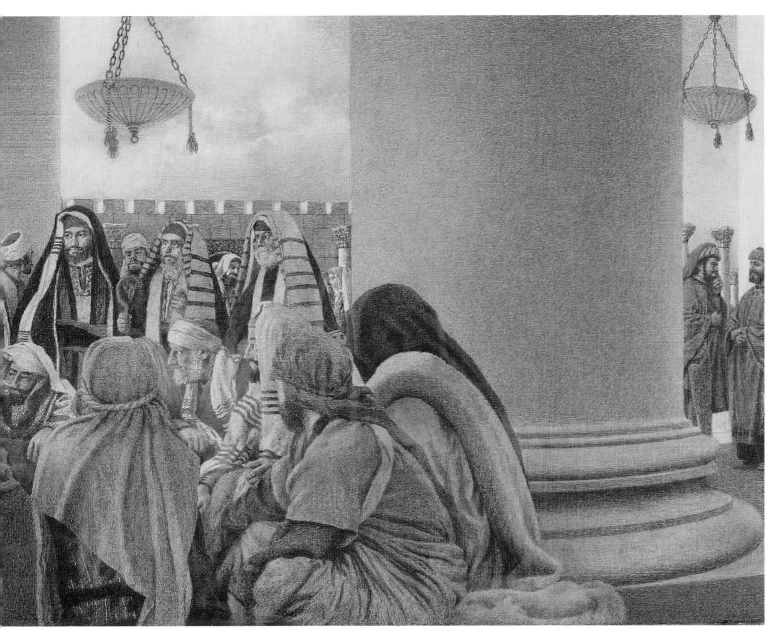

When Jesus was twelve years old, He and His family went to Jerusalem, according to the custom of the Passover feast. As the group they came with began the return to Nazareth, the boy Jesus remained in Jerusalem.

Mary and Joseph had traveled a day's journey before they realized that Jesus was not with them. They hurried back to Jerusalem and looked for Him three days before finding Him in the Temple, listening to and asking questions of the chief teachers. And all who heard Him were amazed at His wisdom.

When Mary and Joseph found Him there, they were astonished. Mary said, "Why have You done this to us? We were worried sick about You. We've looked everywhere for You!"

There must have been a deep sadness in His voice as Jesus answered, "Why did you have to look for Me; didn't you know that I would be here in My Father's House and occupied with My Father's things?"

But they did not understand.

Giving His parents such a painful jolt must have hurt Jesus deeply. But probably the greater pain was that they failed to grasp His meaning. Again and again during His life, He would try to enlighten their minds with the sublime reality of who He was.

If only they had understood!

LUKE 2:41–52

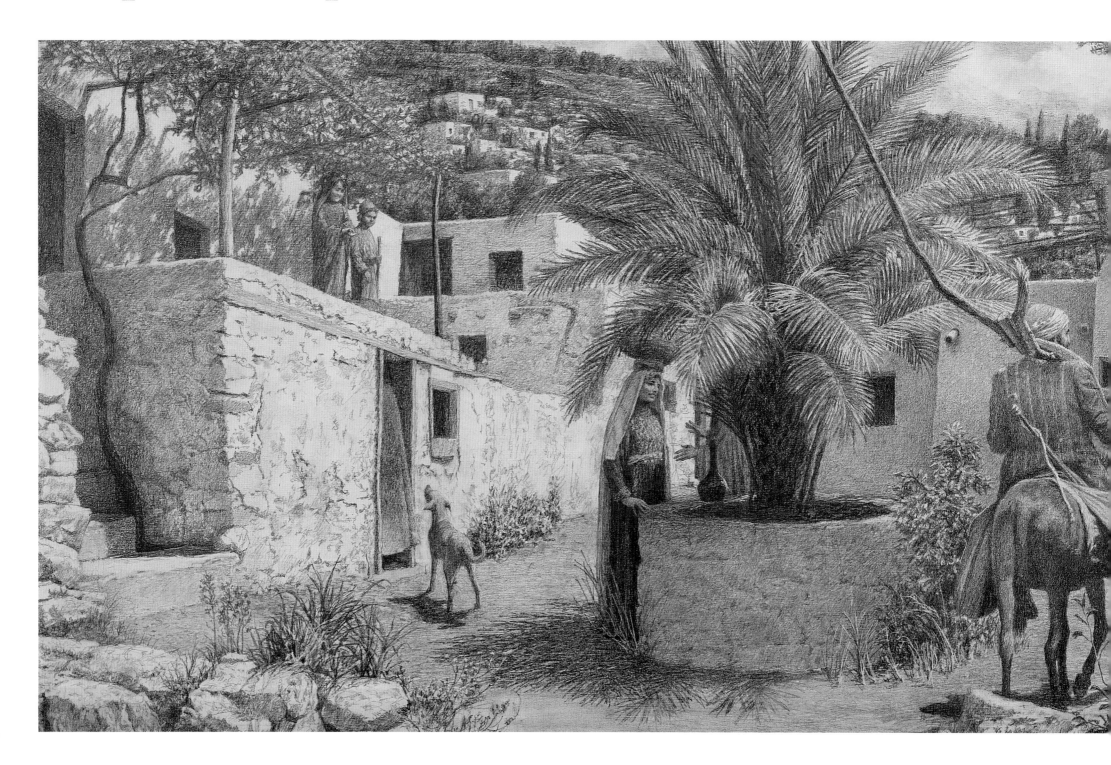

Everyone in the village of Nazareth, and for miles around, knew that Jesus was a dependable, skillful, honest, and considerate carpenter. They knew well how very fortunate they were to have such a workman right there in little old Nazareth.

MARK 6:3; LUKE 2:52

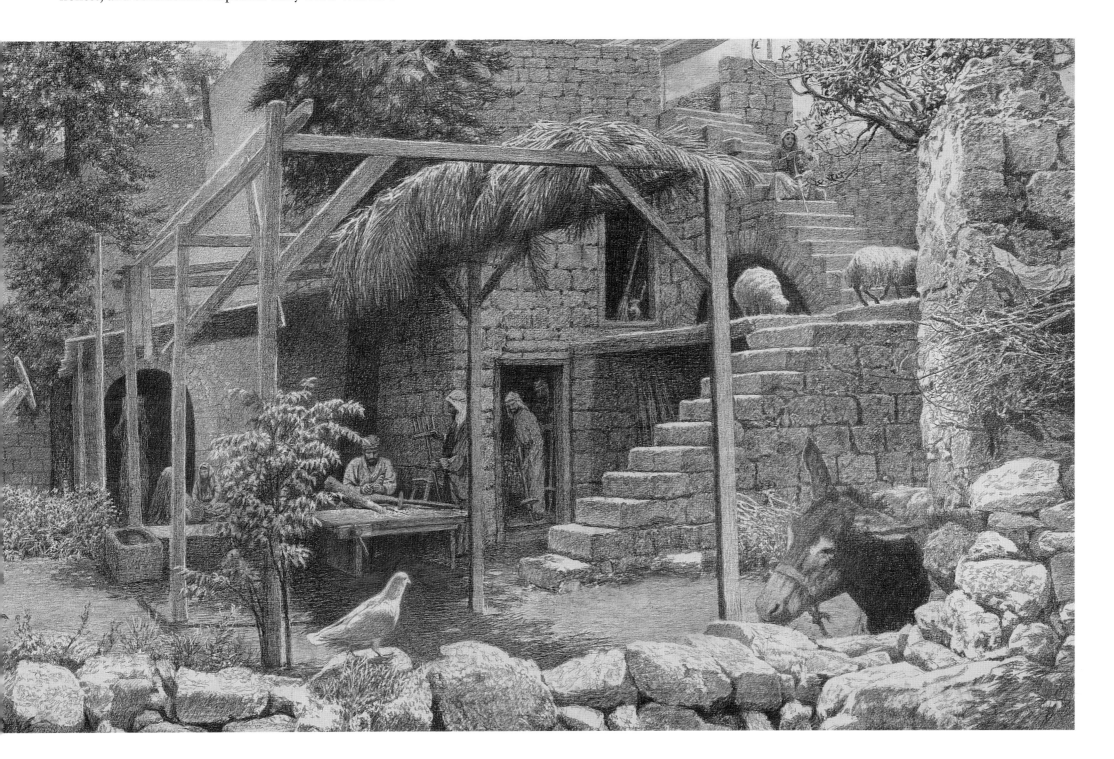

The Baptism

John was baptizing at Bethabara, not far from the Dead Sea, when Jesus came to him to be baptized. Bethabara means "House of the Ford," which suggests a village or town next to a ford of the Jordan. Since the river has changed its course to some extent in the last two thousand years, the most authentic background possible for Jesus' baptism is a scene such as this in the general area.

In subjecting Himself to John's baptism, Jesus officially identified Himself with the people He had come to redeem. This was an act of obedience to the Father, Who sent the Lamb of God to take away the sins of the world.

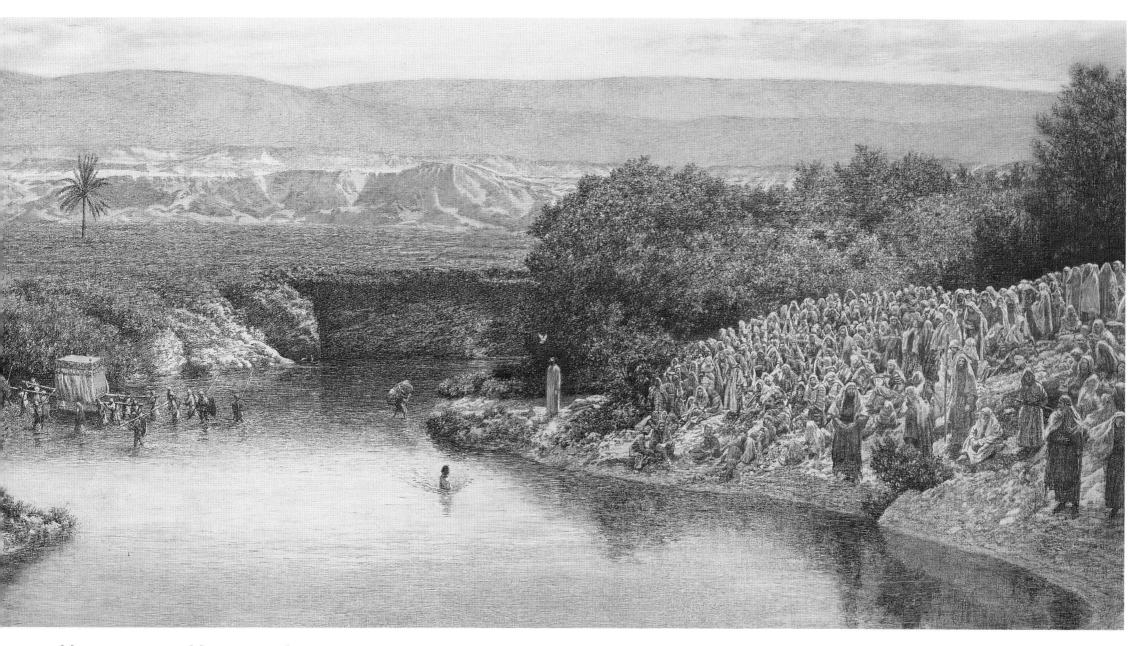

Matthew 3:13–17; Mark 1:9–11; Luke 3:21–22

The First Temptation

The time is early morning.

Mark says that Jesus was in the wilderness with the wild beasts. This calls to mind the ancient days of Adam when man and beast lived in harmony. And it looks forward to the Millennium when *"the wolf will live with the lamb, the leopard will lie down with the goat, the calf and the lion and the yearling together; and a little child will lead them."*

Into this congenial company Satan, pictured here as a dark whirlwind, intruded with his sinister purpose: to persuade Jesus to do something—anything—by the authority of His own will. But Jesus had come to do the will of the Father Who had sent Him. It was as if Satan did not know that Jesus always waited for the Father to tell Him what to do and how to do it.

Three times Satan tempted Him with a "solution" that was very relevant to the situation. In this case, if Jesus turned the stones into bread, He could satisfy his physical hunger—the result of fasting for forty days.

Jesus answered, *"It is written: 'Man does not live on bread alone, but on every word that comes from the mouth of God.'"*

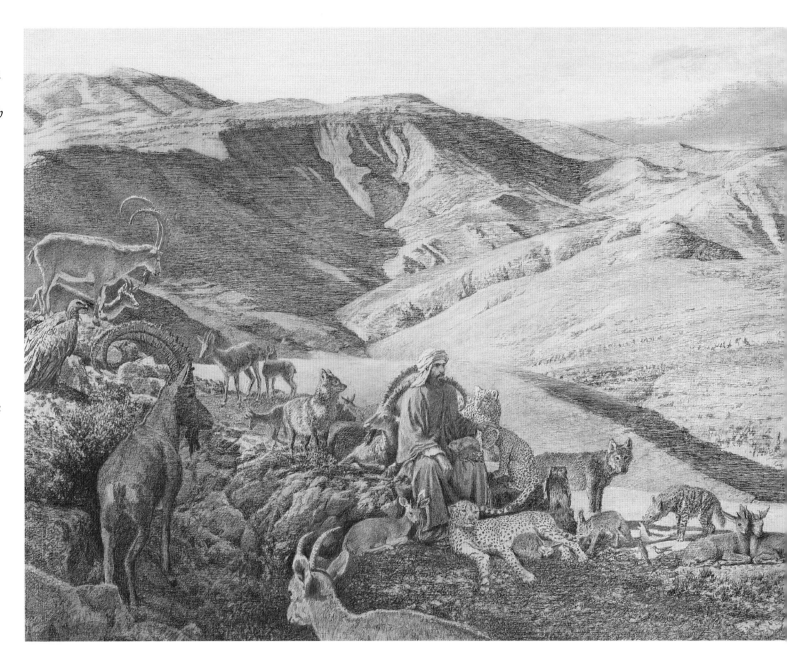

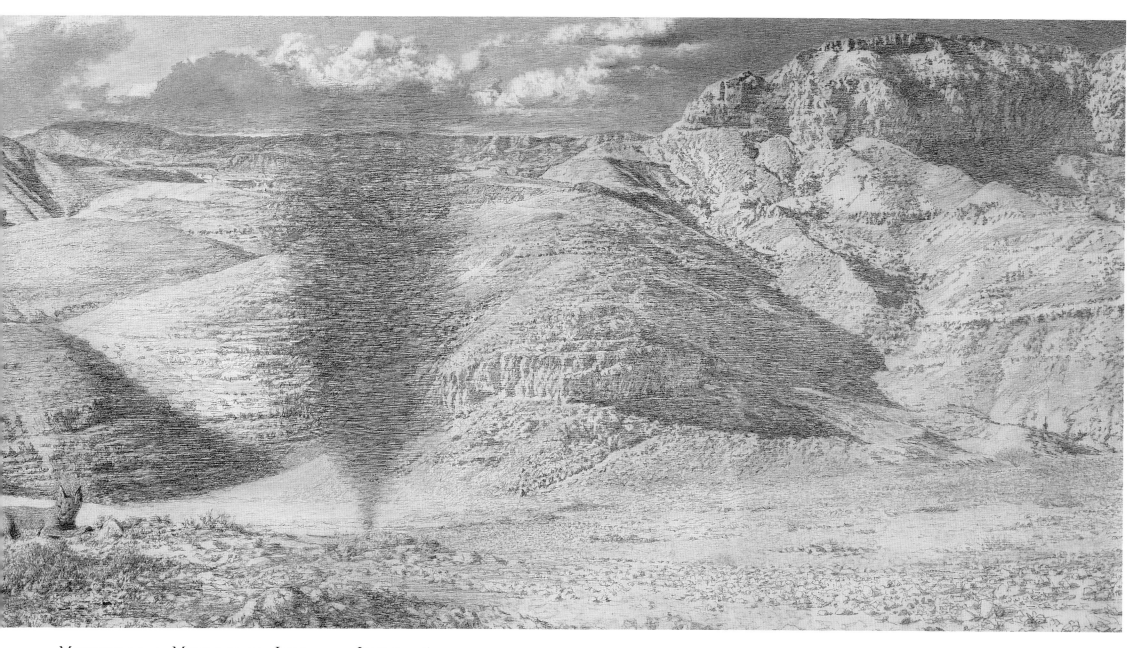

Matthew 4:1–4; Mark 1:12–13; Luke 4:1–4; Isaiah 11:6

The Second Temptation

Satan next took Jesus to a pinnacle of the Temple. The Greek word for "pinnacle" means "little wing." The porch of the Temple had a wing on each side.

This was the proper place for this second temptation for two reasons. First, below the wing, in the Court of Priests, was where the religious leaders assembled to preside over the morning sacrifices. Also, the rabbinical literature of those days taught that the Messiah would begin His mission of deliverance by first appearing on the roof of the Sanctuary and announcing His presence to the leaders of the people. Knowing of this expectation, Satan's suggestion that Jesus cast Himself down into the assembly appeared helpful in promoting the cause.

But it was man's cause, not God's. Man had assumed that the Messiah would arrive with a display of power and pomp, even though God had repeatedly told His people through the prophets that Messiah would first come as a sacrificial lamb.

So the Lamb of God stood firm.

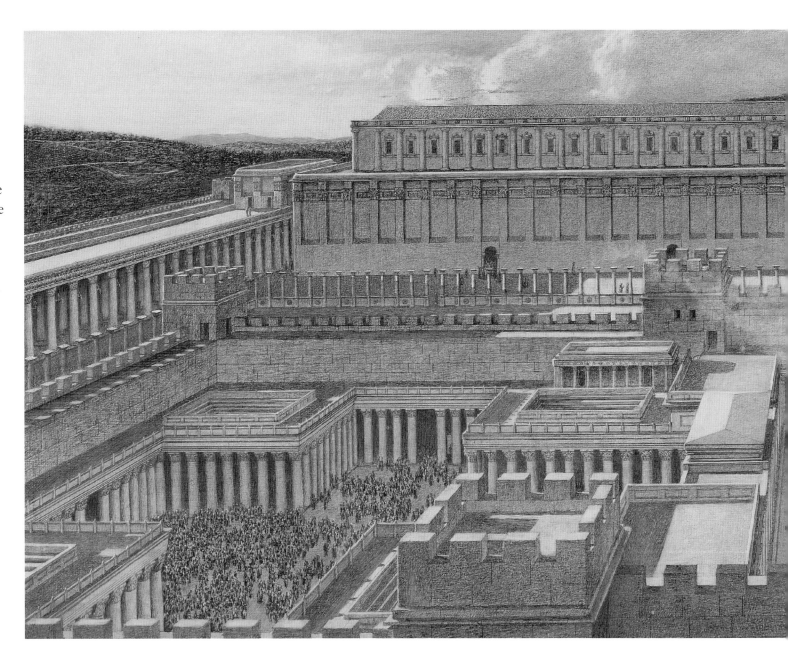

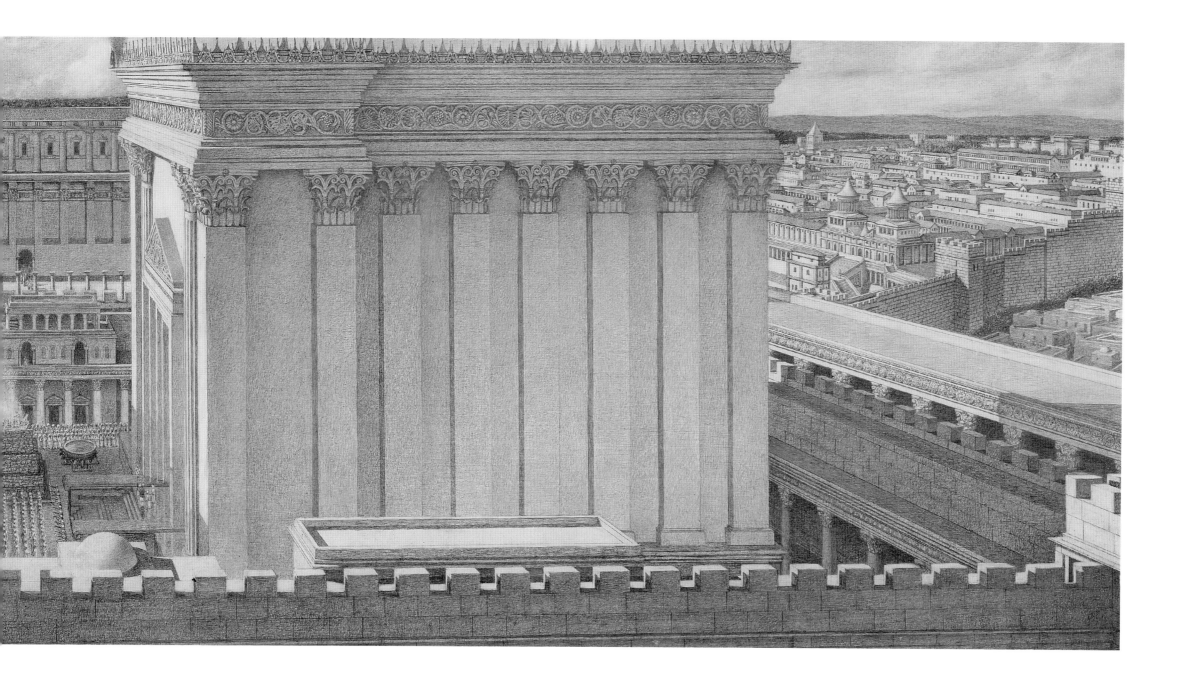

The Third Temptation

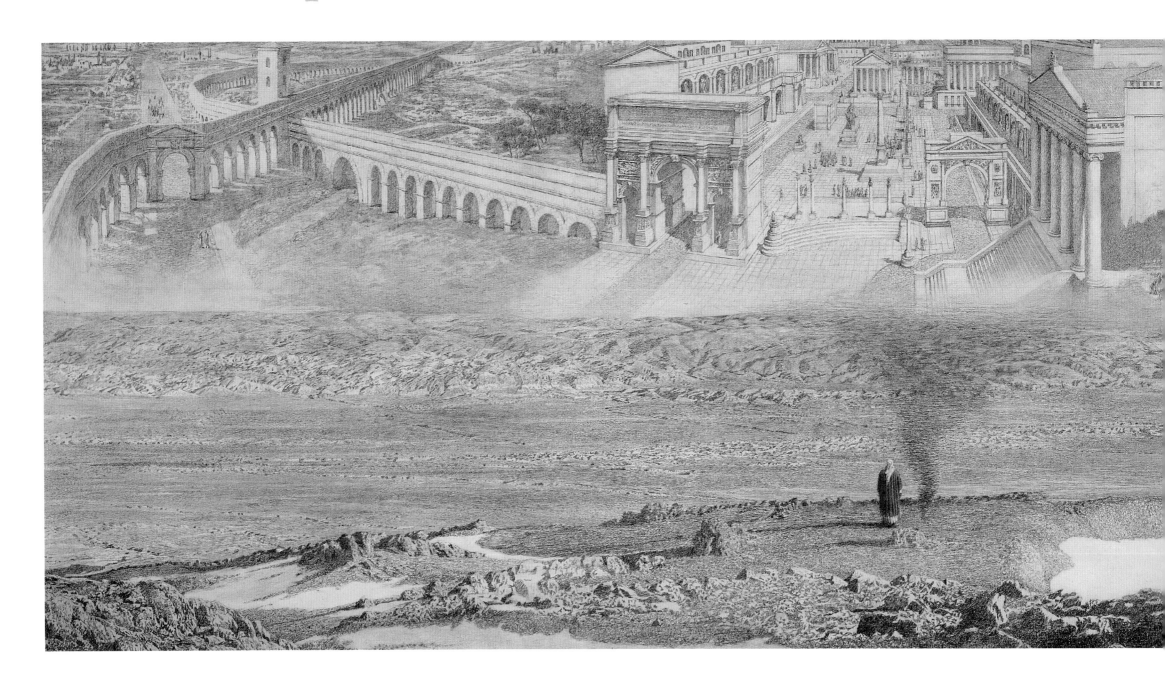

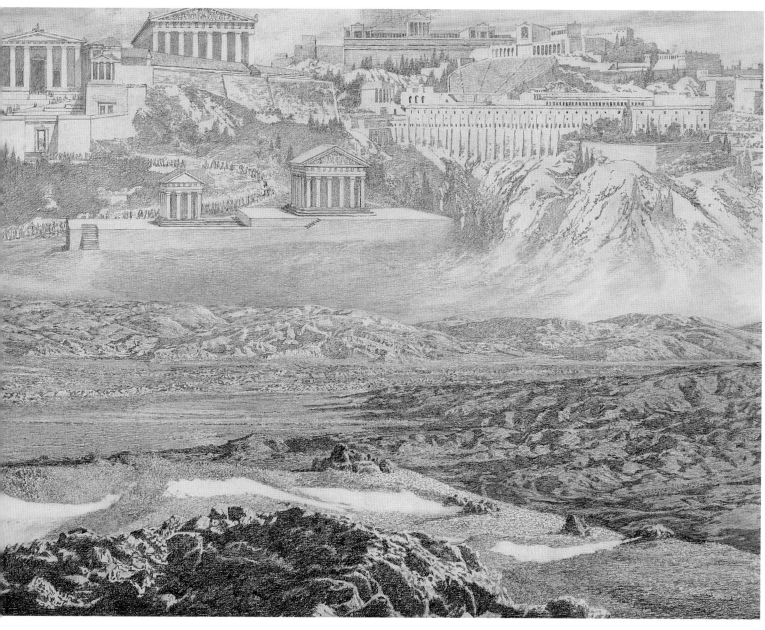

The scene is somewhere on top of Mt. Hermon, which stands on the boundary between Israel and Lebanon as one looks across the Beka'a Valley to the Lebanon mountain range. Since Mt. Hermon is the only *"very high mountain"* in that part of the Middle East, it would seem to be the site of Christ's third temptation. As an outpost on the edge of the Promised Land it looks, with breathtaking view, toward the rest of the world over which Jesus would someday rule. Satan was offering it at once—for an impossible price. But Jesus refused him, saying, *"Away from Me, Satan! For it is written: 'Worship the Lord Your God, and serve Him only.'"*

MATTHEW 4:8–11; LUKE 4:5–8

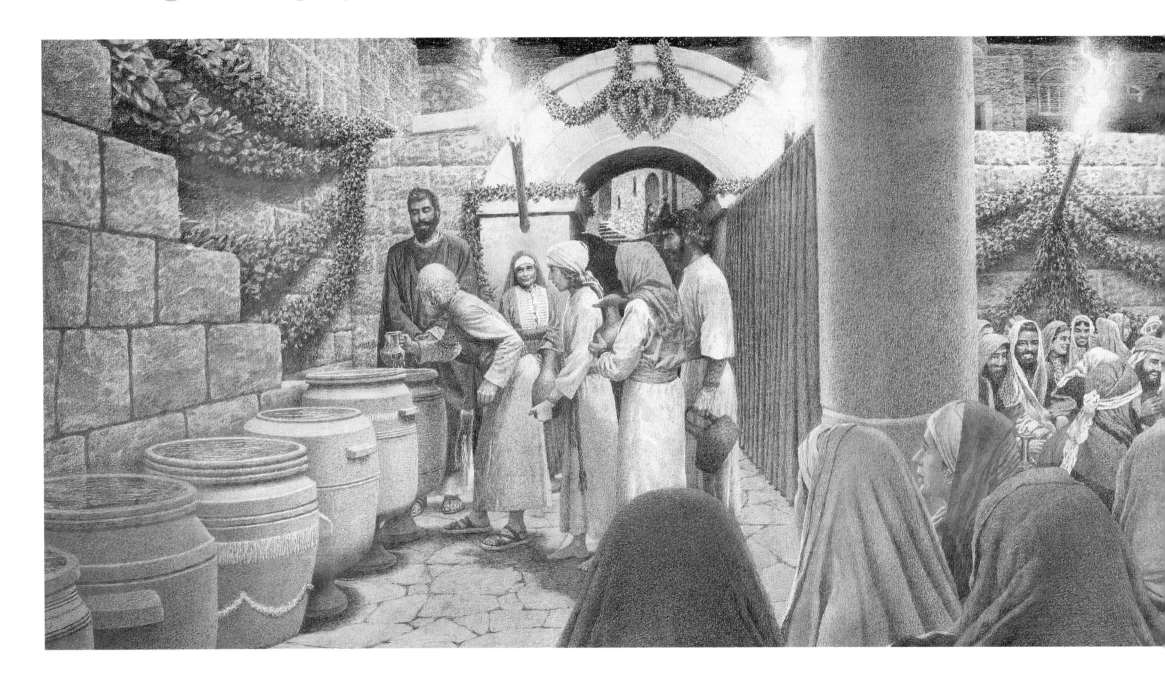

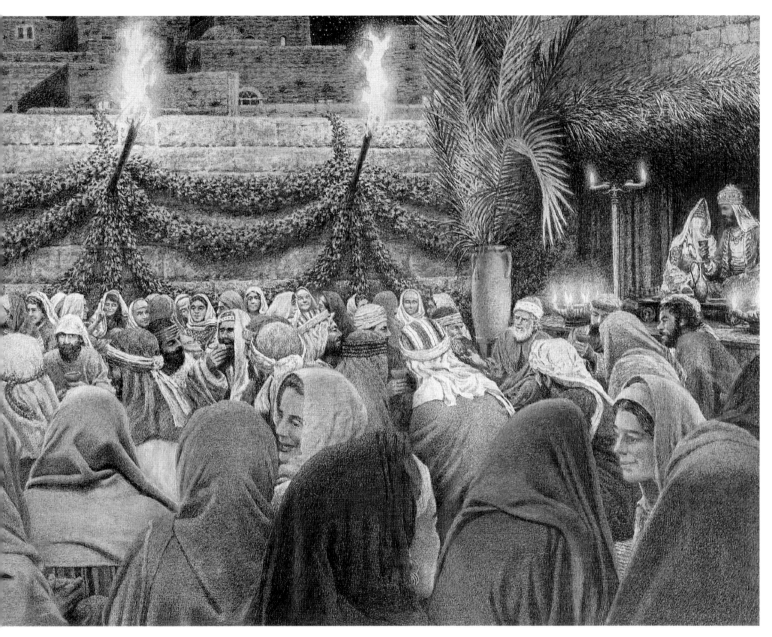

Jesus returned to the place of His baptism where the Father and the Spirit had officially revealed that Jesus was the Messiah. Shortly afterward He arrived in Nazareth with the first six disciples who had come to Him from the crowd at the Jordan River.

There was a wedding ceremony a short distance away in Cana, and the mother of Jesus was there. Jesus and His disciples were also invited.

When the supply of wine at the wedding feast ran out, Mary knew it. She also knew that Jesus had solved every important problem she had encountered over the last fifteen years or so, and she must have expected Him to solve this one—especially now that He had begun His public ministry as Messiah!

Up to this time Jesus must have been very considerate of her wishes. But now He had to let her know that since His baptism their relationship had changed. From that moment on, He would have to say and do only what His Father told Him.

For this reason Jesus said to Mary, *"Dear woman, why do you involve Me?"* That didn't seem to make a very deep impression on her, however, because she immediately began to give instructions to the servants, suggesting that Jesus would do what she wanted. This time Mary's wishes conformed to the Father's will, and the Father used her deep concern and this divinely ordained occasion—which symbolized the marriage of God to His people—to provide Jesus with this magnificent sign that Messiah's mission had officially and publicly begun.

And so Jesus, in obedience to His Heavenly Father, turned the water of purification into the wine of gladness.

Cleansing the Temple

The beginning of miracles at Cana was an expression of kindness and concern for family and friends. There the Messiah began His mission at His earthly home. According to John, the next display of God's power came at His Spiritual Home—the Temple in Jerusalem. He prepared the way for His national ministry by clearing out His Father's House, which was for all people.

The Passover of the Jews was at hand when Jesus went up to Jerusalem. In the Temple He found merchants selling oxen and sheep and doves. The money-changers were in their places doing business also. Outraged at what He saw, Jesus drove the animals out of the Royal Portico, poured out the money-changers' coins and overturned their tables. The fact that they let Him do it appears to be another miracle.

Jesus must have raised His voice when He called the merchants "Thieves!" and ordered them not to make His Father's House a house of merchandise. But the scourge He used for the innocent animals was made of small, painless cords.

Seeing all this reminded the disciples that it was written, *"Zeal for Your house will consume Me."*

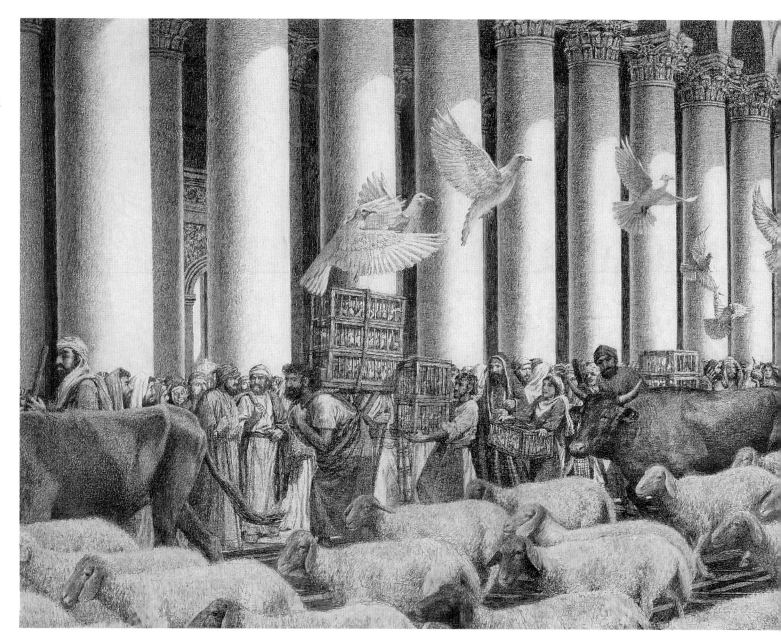

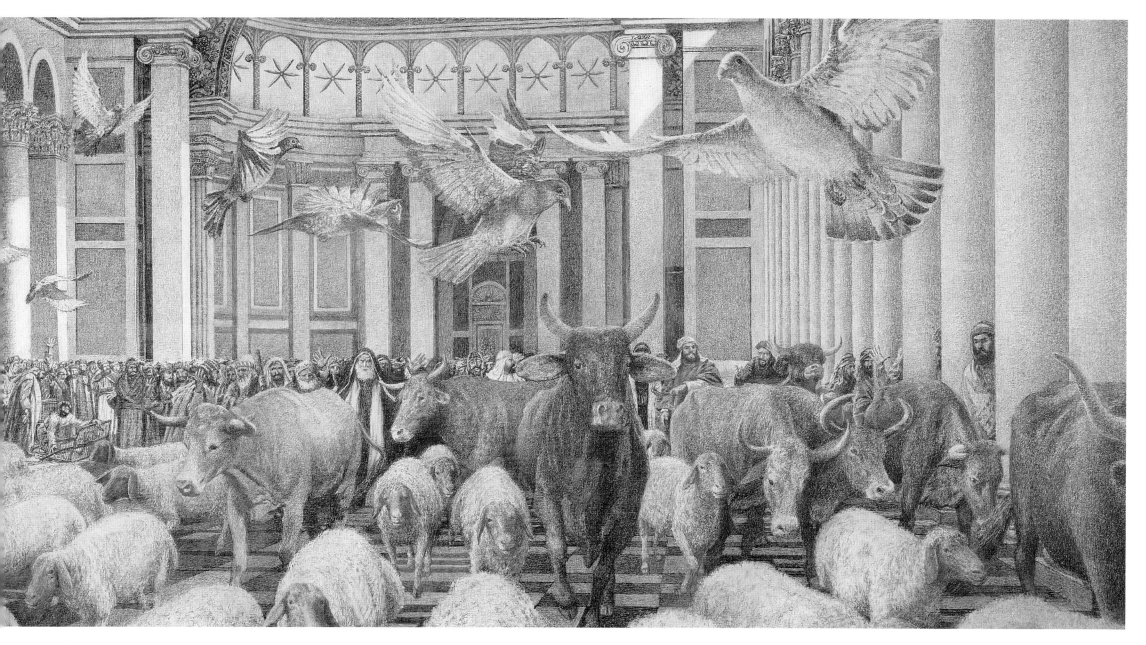

JOHN 2:13–17

35

Nicodemus Visits Jesus

Since John was the only one to write about the visit, he has been included in the picture. The roof setting was chosen because it not only offered an opportunity to show a view of Jerusalem at night, but was also the most likely place for a private meeting since it was usually used as a work area or guest quarters.

Nicodemus must have been a changed man from the time of that visit. Although there is no record that he openly supported Jesus during Jesus' life, both he and a secret disciple, Joseph of Arimathea, opposed the rest of the Sanhedrin when they condemned Jesus to death. When all seemed lost at the cross, the two of them stood firmly in public support of Him. They accepted the shame and loss of respect this would bring them in the place where it counted the most—with the great Sanhedrin.

Nicodemus was an honorable man.

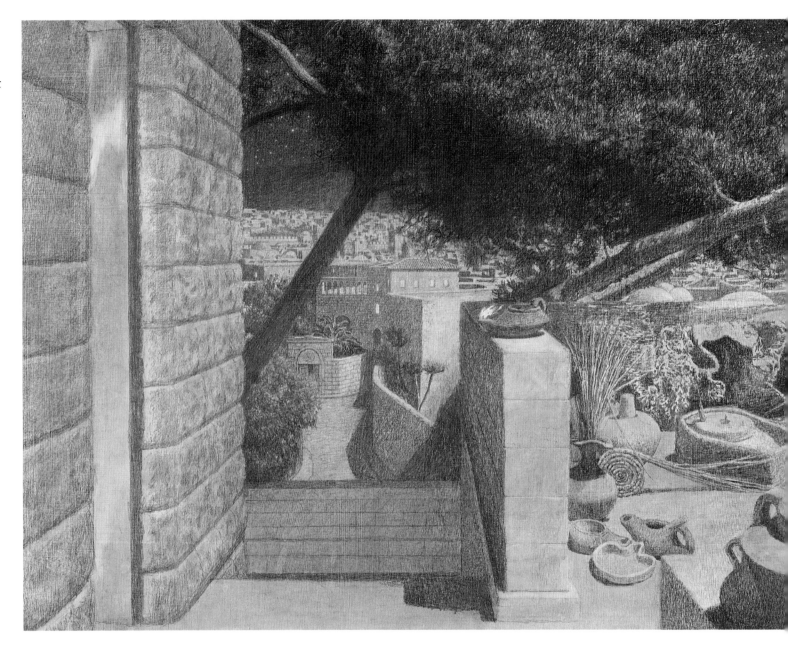

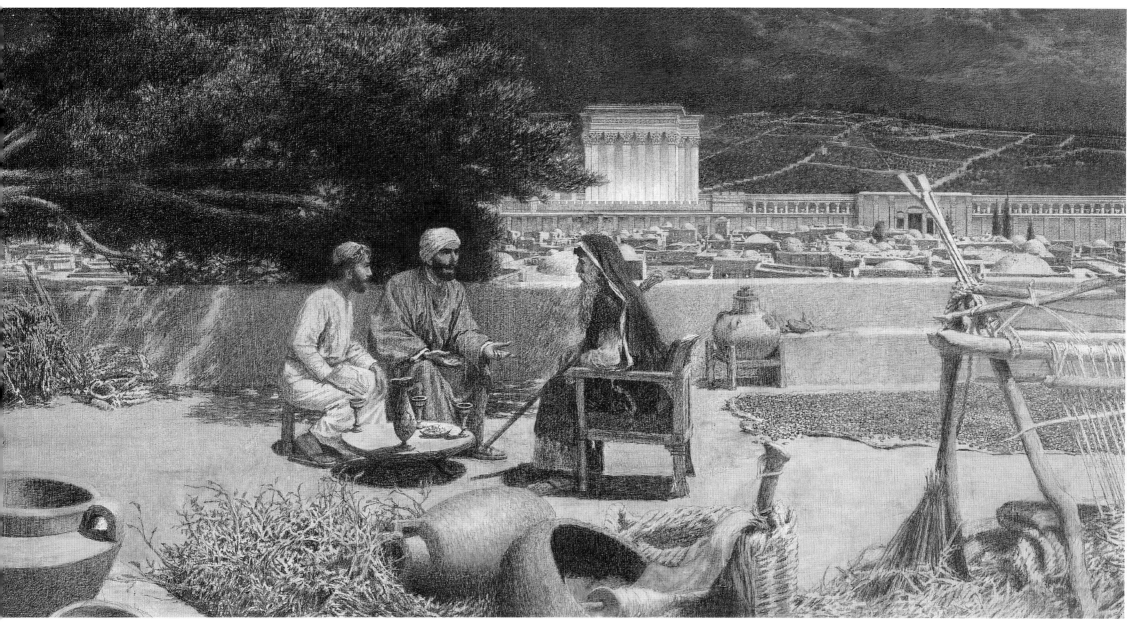

JOHN 3:1–17

The Woman at the Well

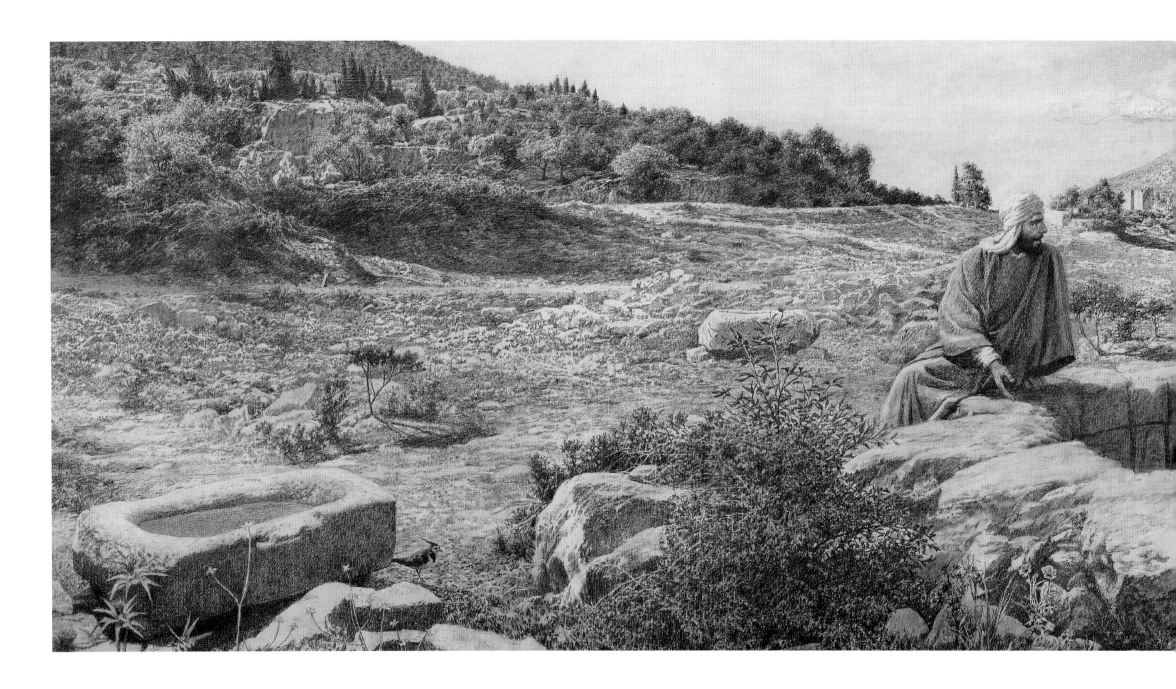

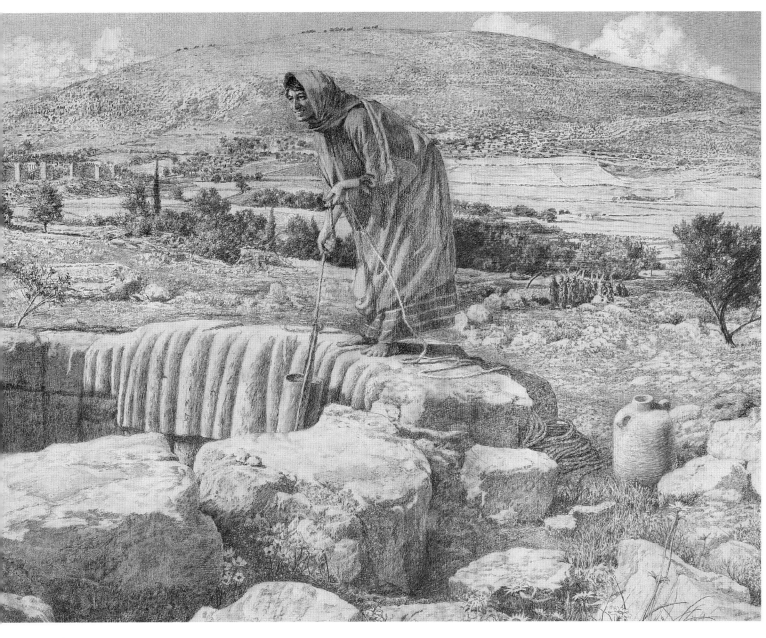

Jacob's well is situated at the base of Mt. Gerizim, which was named "The Mount of Blessing" by Moses in the Old Testament.

As Jesus sits on the Gerizim side of the well, He represents the God of blessings reaching out to the woman, who is shown under Mt. Ebal, which was named "The Mount of the Curse." In the distance, at the foot of Mt. Ebal, lies the village of Sychar in which she lived her unstable and immoral life.

While the Samaritan woman made her way to the well, Jesus listened as the Father revealed to Him the hunger and heartache in her unenlightened soul. In response He reached out and met her needs with directness and compassion. And another lamb was added to the flock.

In her excitement the woman left without her water pot, but in her heart she carried a well of living water.

JOHN 4:5–29

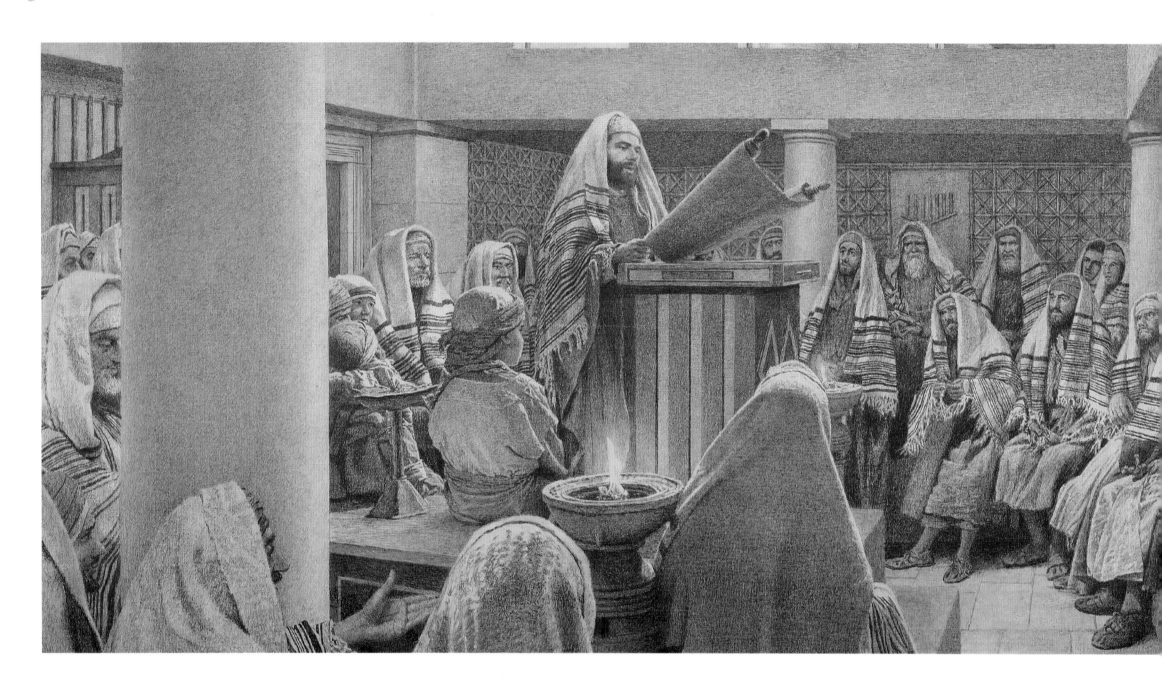

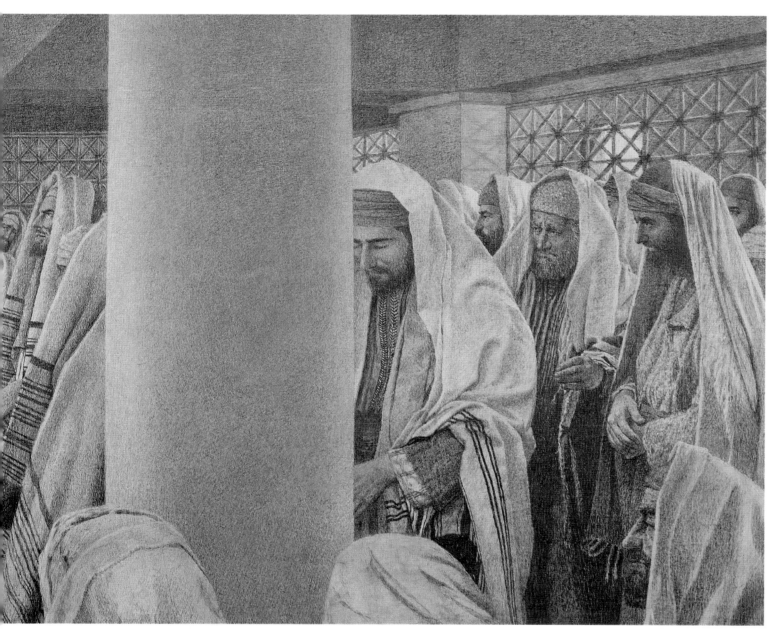

In the village of Nazareth, the synagogue would have been a small one. It was here that Jesus first read this prophecy of the coming Messiah:

"The Spirit of the Lord is on Me,
because He has anointed Me
to preach good news to the poor.
He has sent Me
to proclaim freedom for the prisoners
and recovery of sight for the blind,
to release the oppressed,
to proclaim the year of the Lord's favor."

Then He said to them, *"Today this Scripture is fulfilled in your hearing."*

When Jesus proclaimed that He was the Messiah, the Nazarenes did not believe, for although they respected Him personally, His origin was questionable. *Surely,* they thought, *such a person could not qualify for such a high honor!*

Luke 4:16–28

41

Rejection at Nazareth

When Jesus stood before the leaders of the synagogue and announced that He was their long-awaited Messiah, they were outraged. *What blasphemy!* they thought.

In their anger they cast Him out of the town and led Him to the edge of the hill on which Nazareth was built, fully intending to throw Him to His death. But Jesus passed right through the crowd and continued on His way, leaving His hometown behind.

In this scene, the figure of Jesus is the tiny speck on the road in the far distance (extreme left) as He journeys to Capernaum.

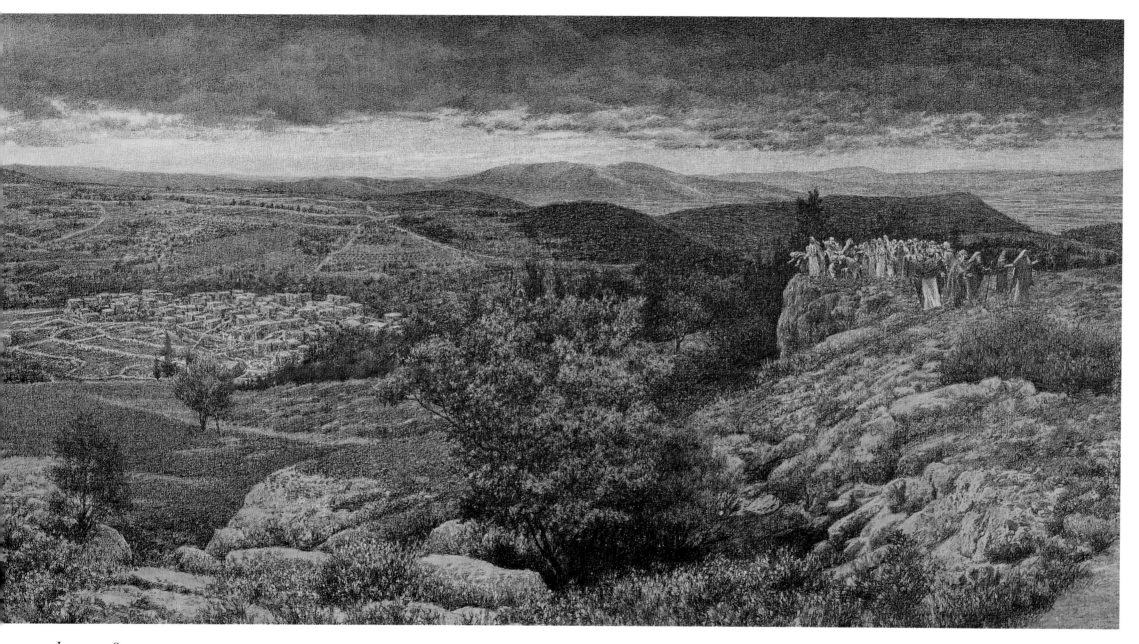

Luke 4:28–30

Capernaum

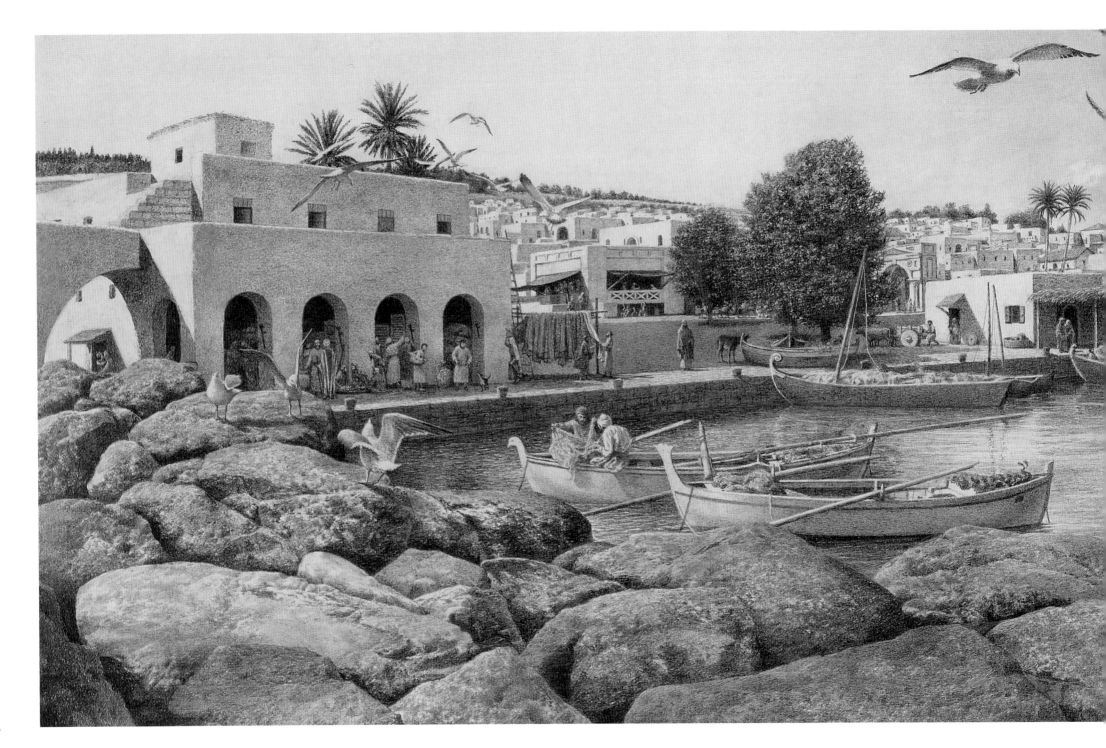

Jesus came to Capernaum, by the Sea of Galilee, where He would live with friends who really believed in Him for the remainder of His earthly ministry. This was to fulfill Isaiah's prophecy:

"*Land of Zebulun and land of Naphtali,*
the way to the sea, along the Jordan,
Galilee of the Gentiles—
the people living in darkness have seen a great light."

MATTHEW 4:13–16, QUOTING ISAIAH 9:1–2

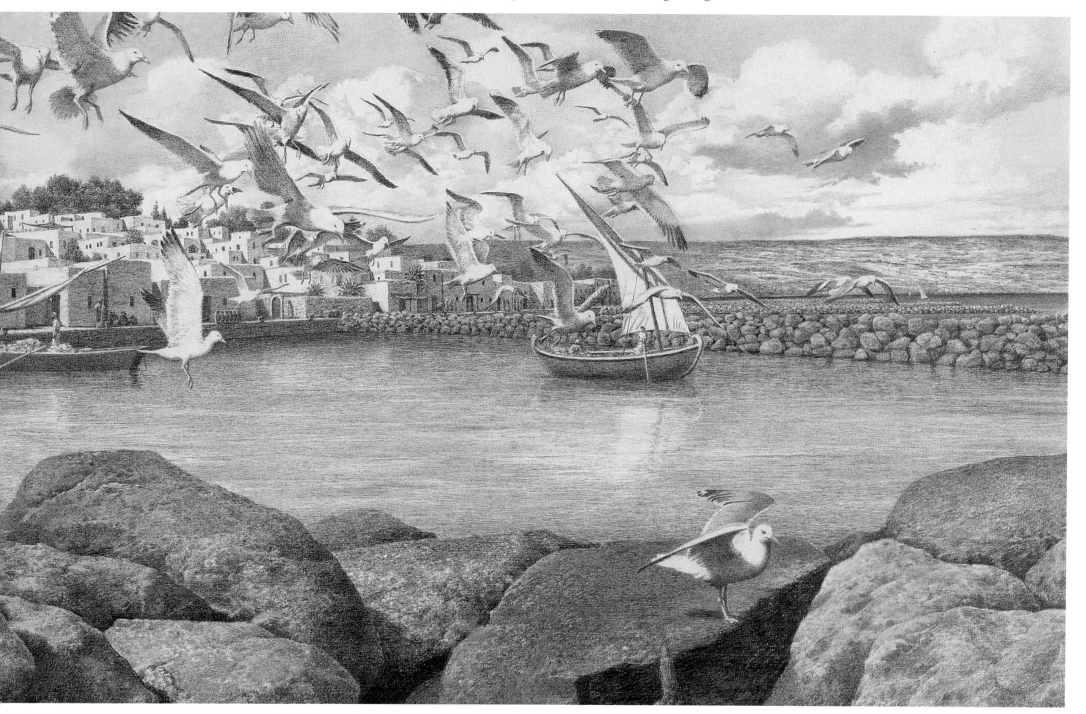

The Call of the Four Fishermen

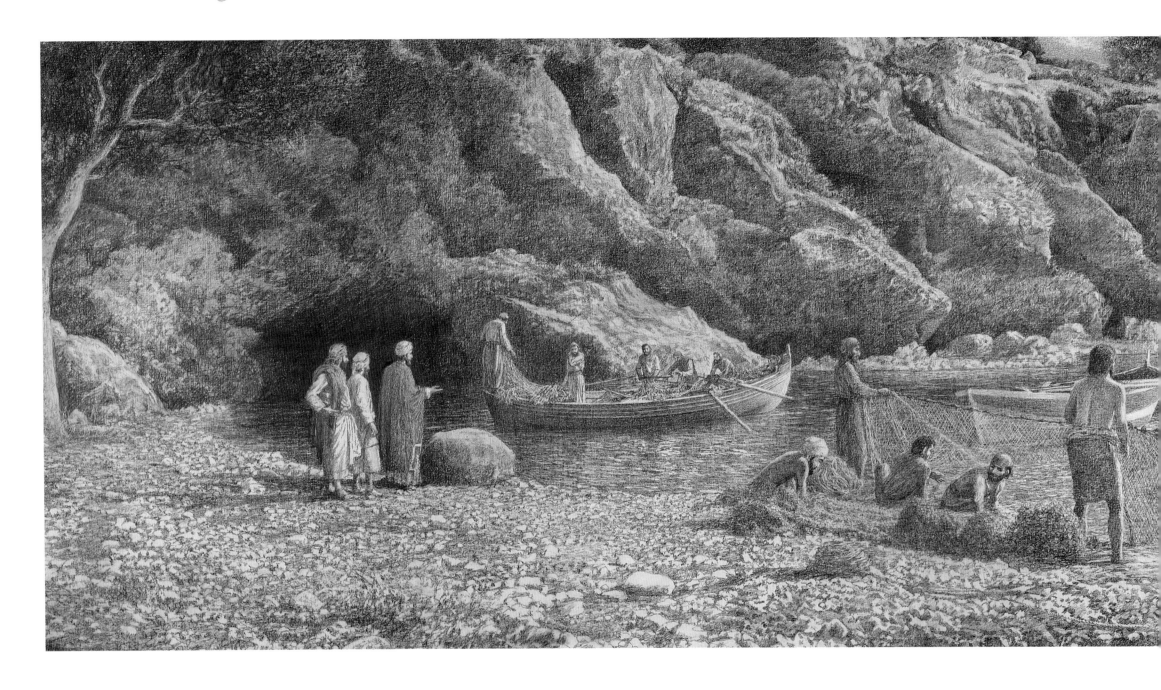

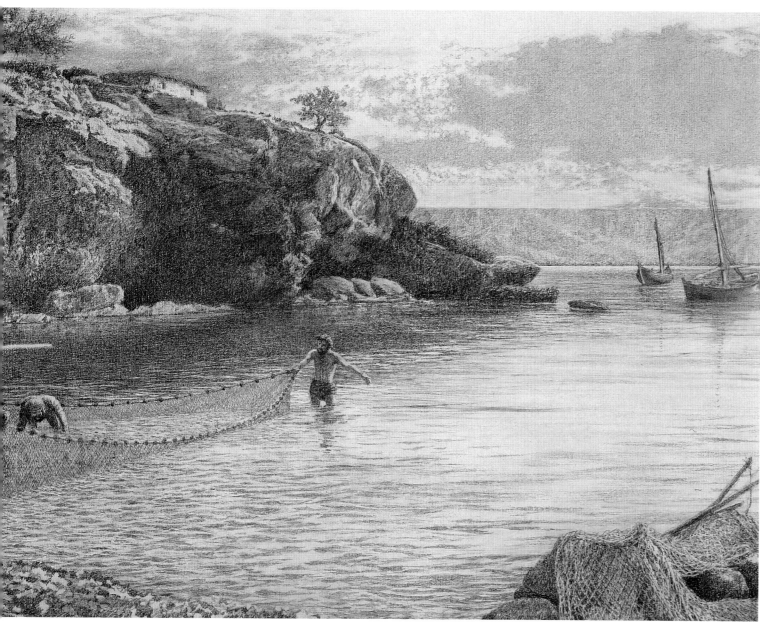

Walking along by the Sea of Galilee, Jesus saw Simon and his brother Andrew casting a net into the water. He said to them, *"Come follow Me, and I will make you fishers of men."* Immediately they dropped their nets, draping them over a nearby rock, and followed.

Going on a little further, Jesus saw two more brothers mending nets in their boat with their father, Zebedee. When Jesus called James and John, they left their father in the boat with the hired servants and also followed Him.

MATTHEW 4:18–22; MARK 1:16–20

The Call of Matthew

Here Matthew is busy on the job when Jesus interrupts him and offers an opportunity this tax collector can't refuse. Meanwhile, the other disciples are waiting outside the tax office, no doubt wondering

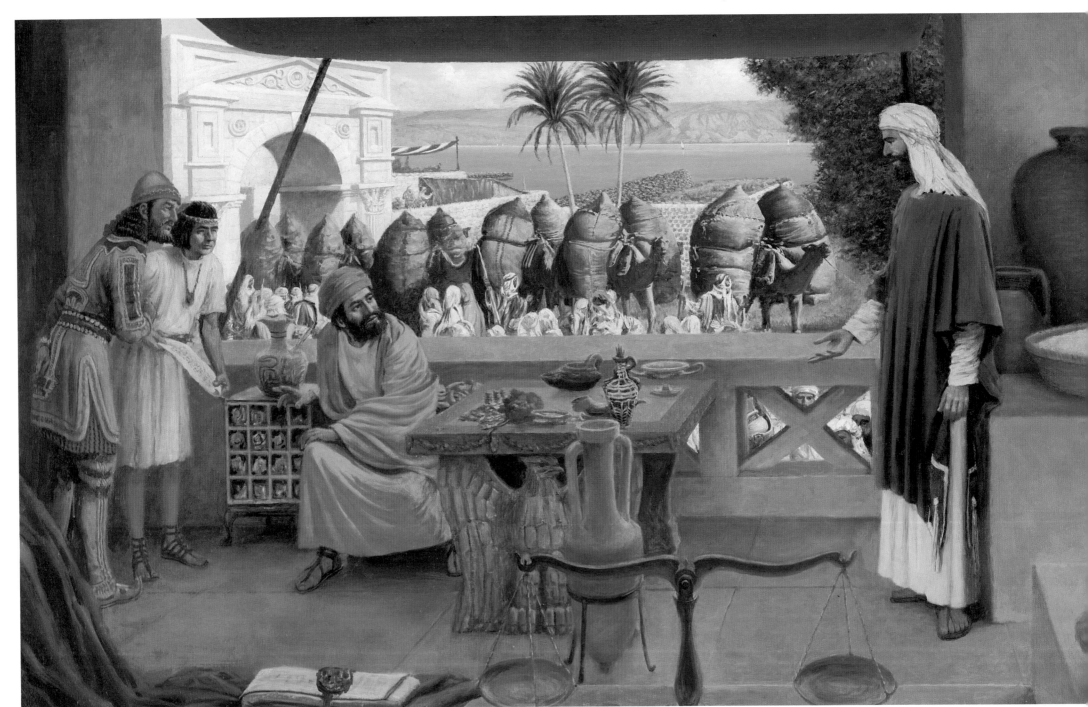

what business Jesus could possibly have in that most despised place.

It seems likely that Matthew already knew of Jesus and respected Him; so the moment he was invited to follow Jesus, Matthew stopped collecting money and started telling people of an eternal treasure they could not lose.

MATTHEW 9:9
MARK 2:13–14
LUKE 5:27–28

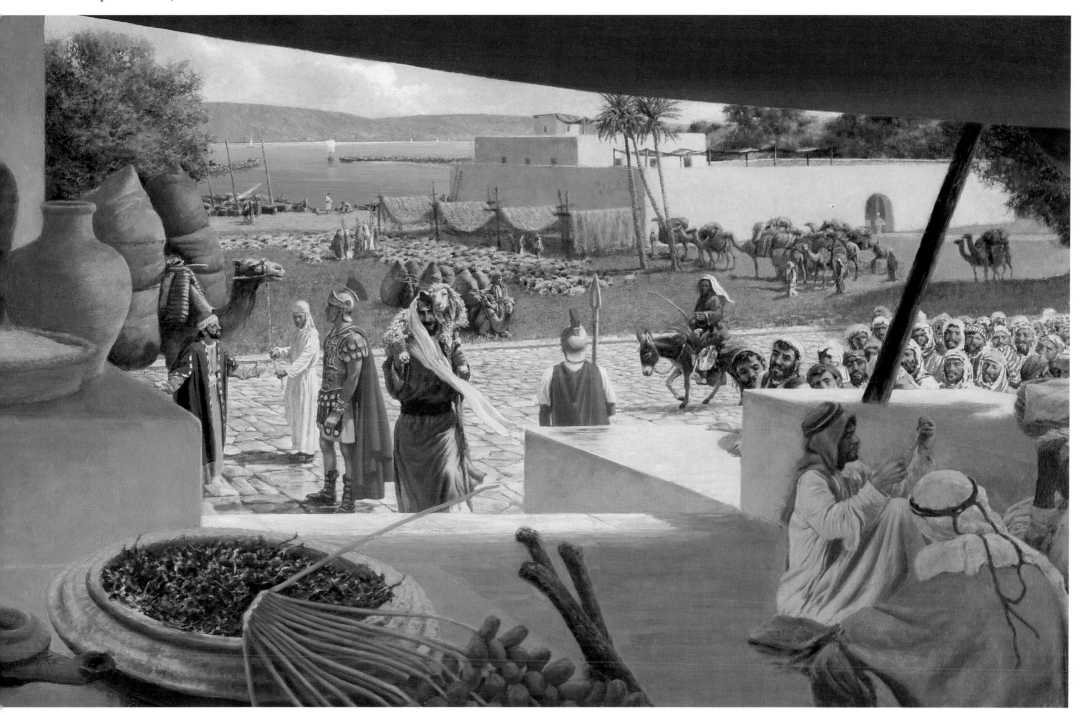

Night of Prayer

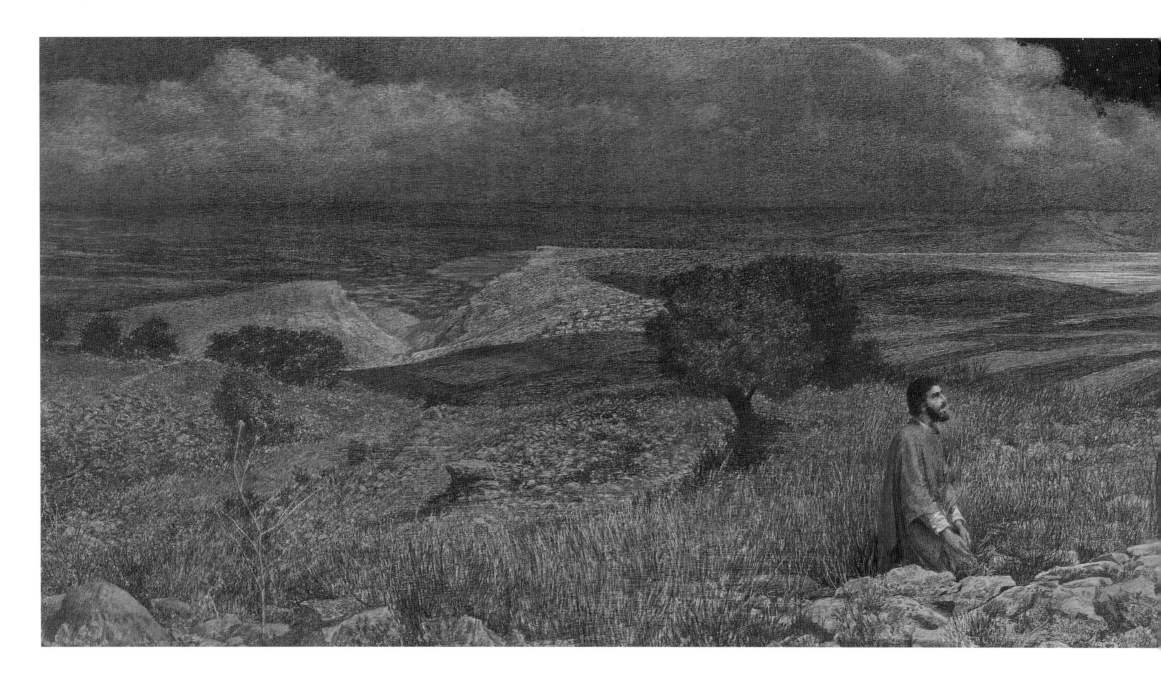

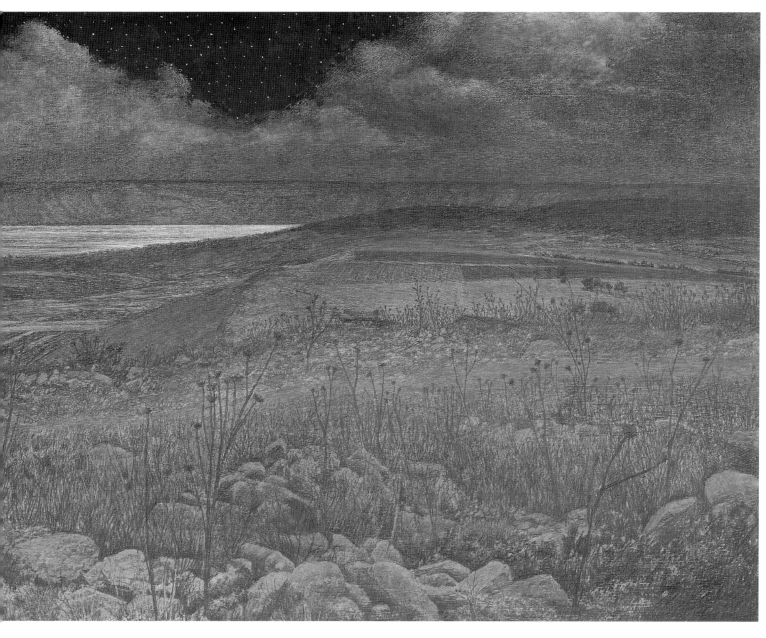

One day Jesus called to those who were with Him to go up the mountainside to the top of Mt. Hattin. After spending the night in prayer, Jesus returned to them when it was day and chose from all His followers the twelve who were to become His inner circle— the apostles.

MARK 3:13–19; LUKE 6:12–16

The Sermon on the Mount

This scene shows the only site in Galilee where the Sermon on the Mount could have taken place, according to the descriptions in Matthew and Luke. The foreground is the lower slope of Mt. Hattin where it meets the plain. Jesus had spent the previous night on the flat top of the mountain praying to the Father, and in the morning had selected the twelve apostles out of the many disciples who were with Him.

Luke: *"He went down with them and stood on a level place. A large crowd of His disciples was there and a great number of people from all over Judea, from Jerusalem, and from the coast of Tyre and Sidon, who had come to hear Him and to be healed of their diseases. Those troubled by evil spirits were cured, and the people all tried to touch Him, because power was coming from Him and healing them all."*

Matthew: *"Now when He saw the crowds, He went up on a mountainside and sat down. His disciples came to Him, and He began to teach them. . . ."*

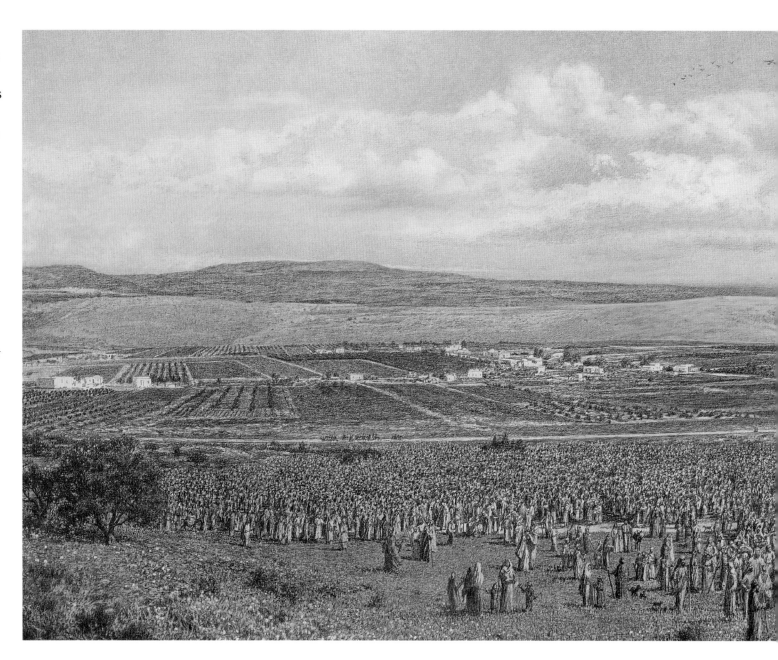

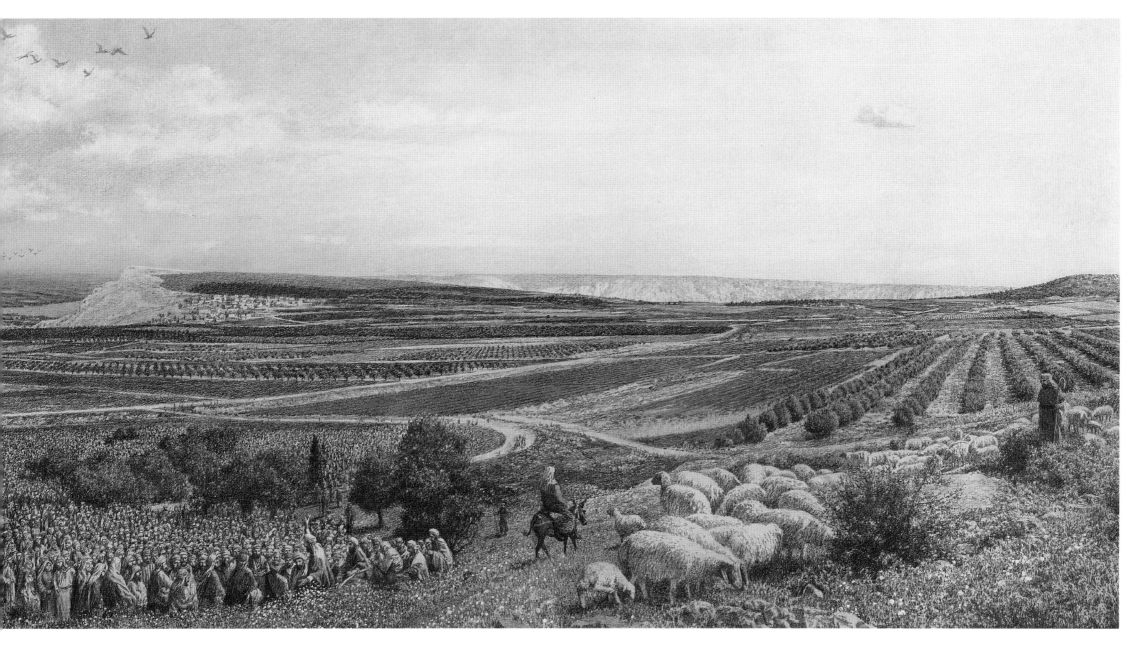

Matthew 5:1–2; Luke 6:17–49

Raising the Widow's Son at Nain

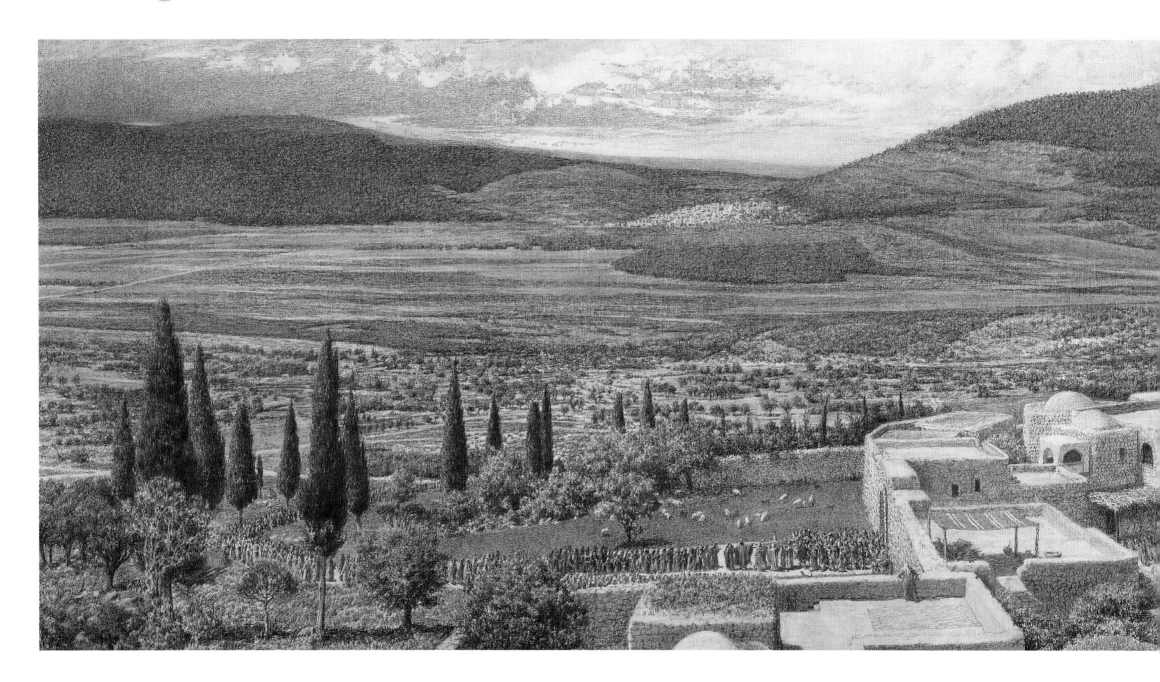

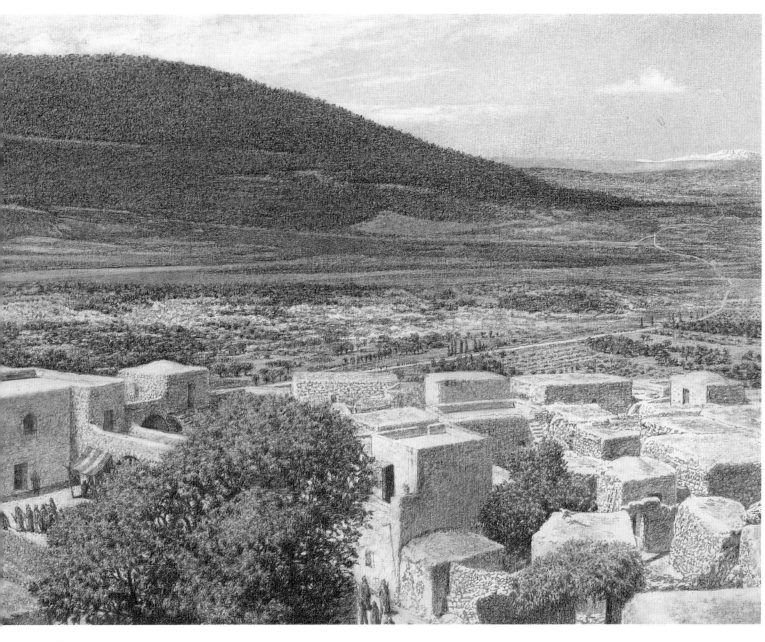

Jesus visited the city called Nain with His disciples and a great multitude. Arriving at the city gate, He and His followers met a group of mourners carrying the body of a dead boy, the only son of his mother. Struck with compassion at this sight, Jesus said to her, *"Don't cry."* Then He came near and touched the coffin and said, *"Young man, I say to you, get up!"*

And the boy, who only moments before had been dead, sat up and began to speak!

In this scene Jesus is giving back to the widow her son as the crowd looks on in amazement. We can easily imagine that the rest of the day was given over to joyful celebration with Jesus in their midst. It was a day they would never forget.

LUKE 7:11–17

55

Deliverance for the Demoniac

When Jesus came to the other side of the Sea of Galilee, into the country of the Gerasenes, He was confronted by a man possessed by a legion of devils.

Jesus cast out the devils and, at their request, allowed them to enter a great herd of swine feeding on a hillside some distance away. The swine immediately stampeded down the side of the hill and drowned themselves in the water.

It's hard to say why Jesus would send the demons into a herd of pigs. It might be that He wanted to show God's disapproval of domestic swine in the Promised Land—a practice He had expressly forbidden. The really important event, though, is happening in the field on the right side of the picture. If you look closely you can see the first act of a soul set free.

The man is kneeling in adoration and gratitude at the feet of the Savior.

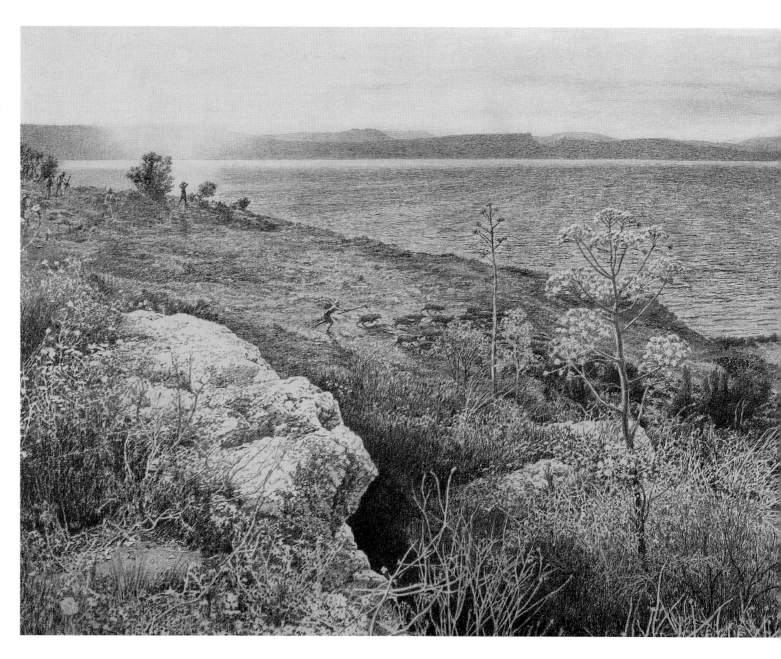

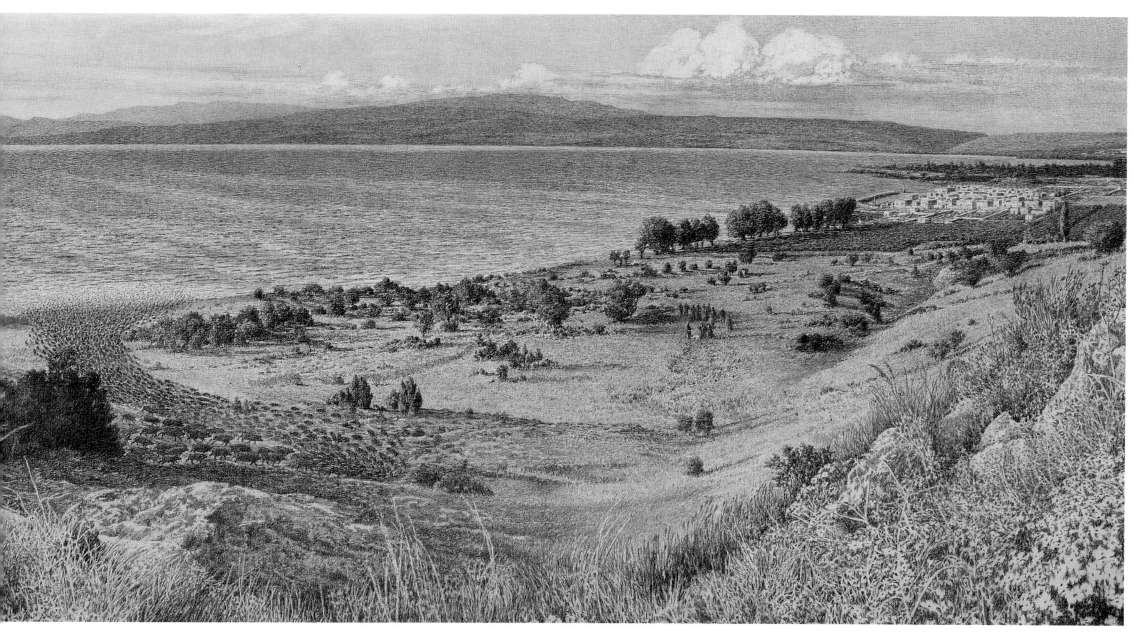

MATTHEW 8:28–34; MARK 5:1–20; LUKE 8:26–39

Feeding the Five Thousand

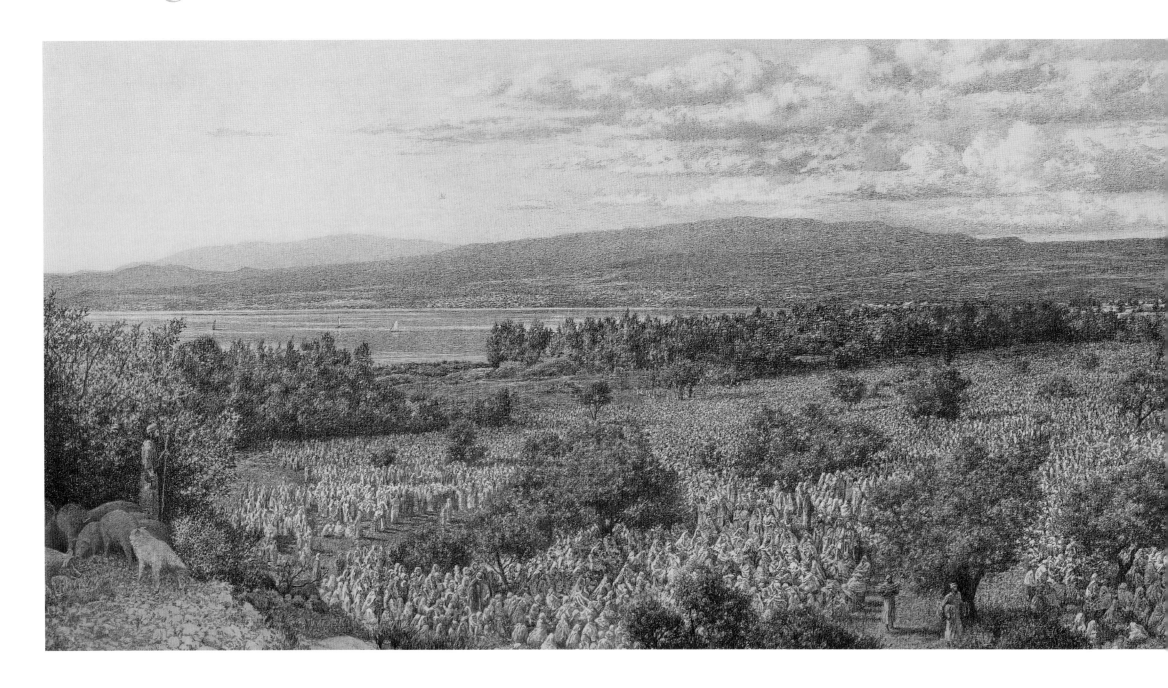

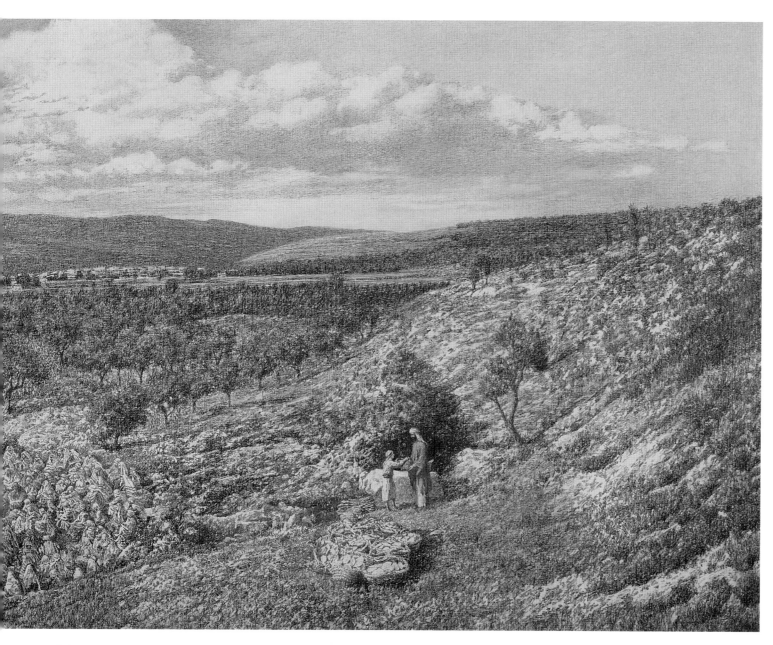

The scene for this miracle is slightly north of the village of Kersa and a short distance from Bethsaida on the northeast angle of the Sea of Galilee. The town can be seen in the distance on the right.

Jesus journeyed across the sea to find a quiet place to rest. But the people followed Him. Exactly how large the crowd was is uncertain since there were also women and children present. Instead of resting, He welcomed them, healed their sick, and spoke to them about the Kingdom of God.

Late in the day, Jesus saw that the people were growing tired and hungry, so He decided to feed them from the five loaves and two fishes provided by a young boy.

At Jesus' instruction, the disciples organized the crowd into groups of fifty and a hundred. While they were doing this, it woud seem likely that people from the different groups would bring their empty baskets to Jesus. The boy would help by setting the baskets aside as Jesus blessed and filled them, so that when the disciples returned they could distribute the full baskets to those who had brought them.

It would be interesting to know how full the young lad's basket was after Jesus used it.

Surely they were the best loaves and fishes that boy would ever eat.

MATTHEW 14:13–21; MARK 6:31–44; LUKE 9:10–17; JOHN 6:1–13

Walking on the Water

After feeding the five thousand, Jesus sensed that the multitude wanted to forcefully take Him and make Him their king. He urged the disciples to get into a nearby boat and to cross over to the other side of the Sea of Galilee. Then, after sending the multitude away, Jesus went up into the mountain alone to pray.

As the night wore on, a strong wind began to blow, churning up the seas in great waves and tossing the boat about. In the early hours of the morning, Jesus came down from the mountain and approached the disciples in the boat, walking on the water.

When the disciples saw Jesus, they were terrified and thought He was a ghost. Immediately Jesus spoke to them, urging them not to be afraid and assuring them it was Him.

Peter spoke up impulsively, asking that if it was indeed the Lord approaching, He should call Peter to walk to Him across the storm-tossed sea.

Jesus responded by telling Peter to come—whereupon he stepped boldly out of the boat onto the water and began walking toward the Lord. But when Peter saw the effects of the wind (shown here by a big wave), he was gripped by fear and began to sink. Fearing for his life, Peter cried out, *"Lord, save me!"*

Jesus immediately reached out His hand, catching Peter, and together they walked back to the boat.

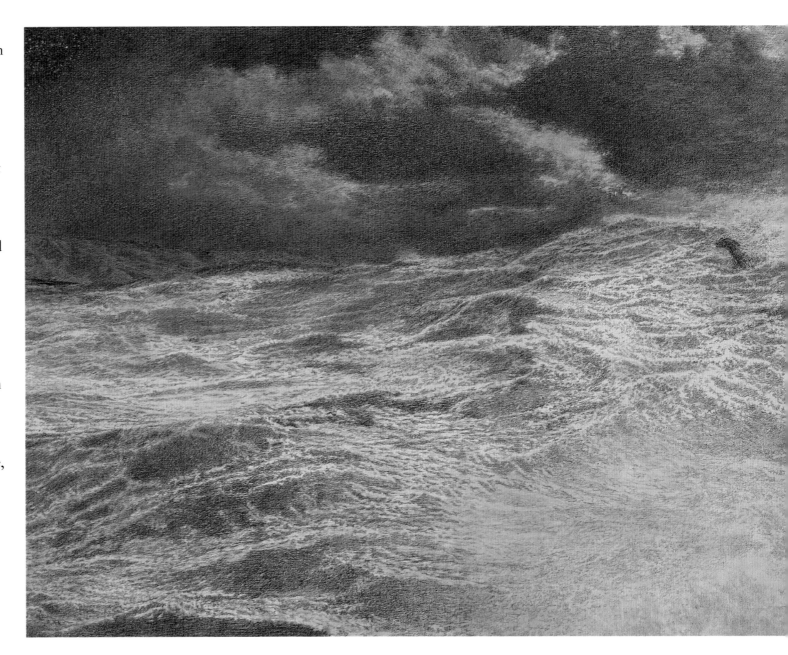

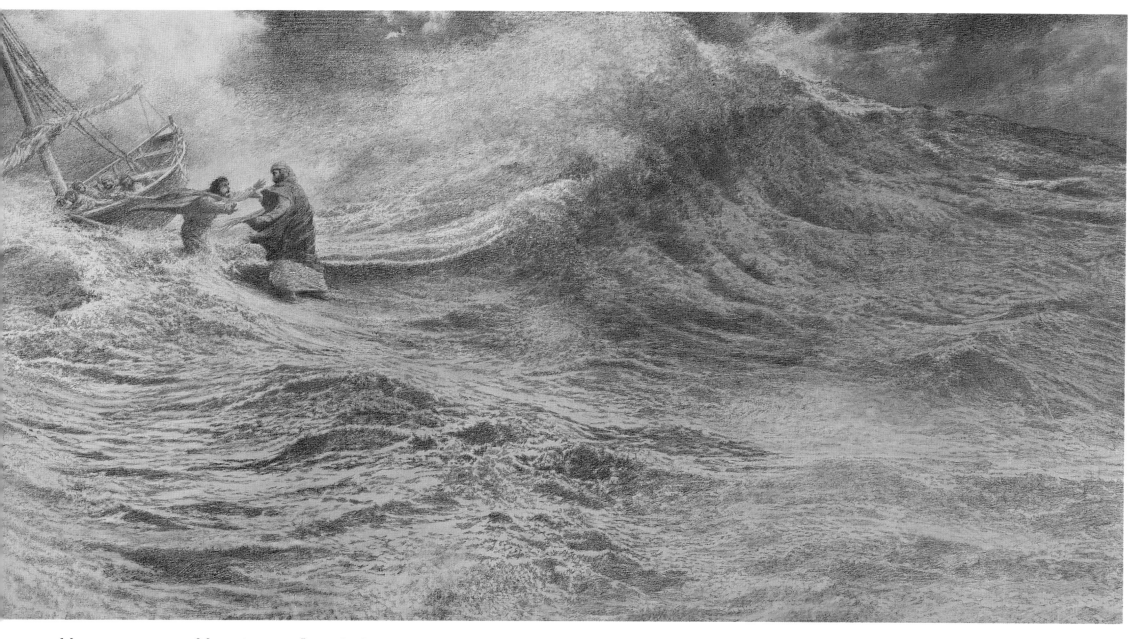

Matthew 14:24–33; Mark 6:47–52; John 6:16–21

Healing in Gennesaret

When Jesus and His disciples had crossed over to the other side of the Sea of Galilee, they came to Gennesaret. Wherever Jesus went—whether to the villages, the cities, or

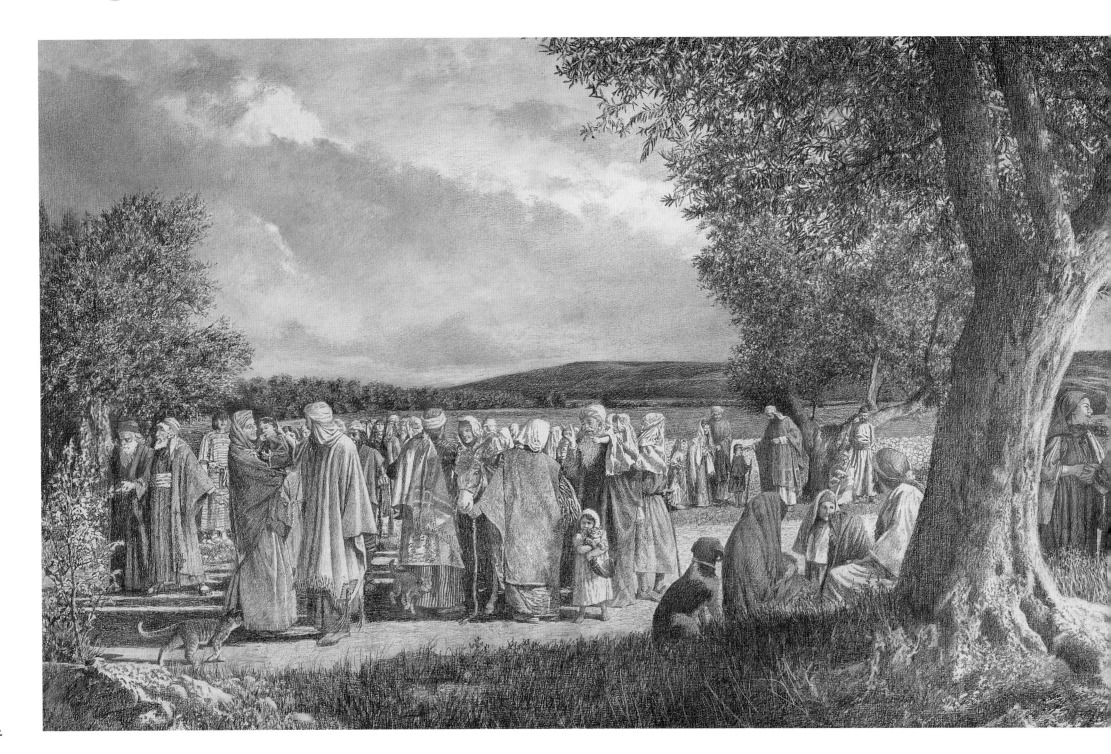

the countryside—the people of that region brought Him all who were infirm. They knew that if the sick could just touch the hem of His garment, they would be healed.

This scene shows the plain of Gennesaret with the flat top of Mt. Hattin in the distance, as well as the plain at its foot where Jesus preached the Sermon on the Mount.

MATTHEW 14:34–36; MARK 6:53–56

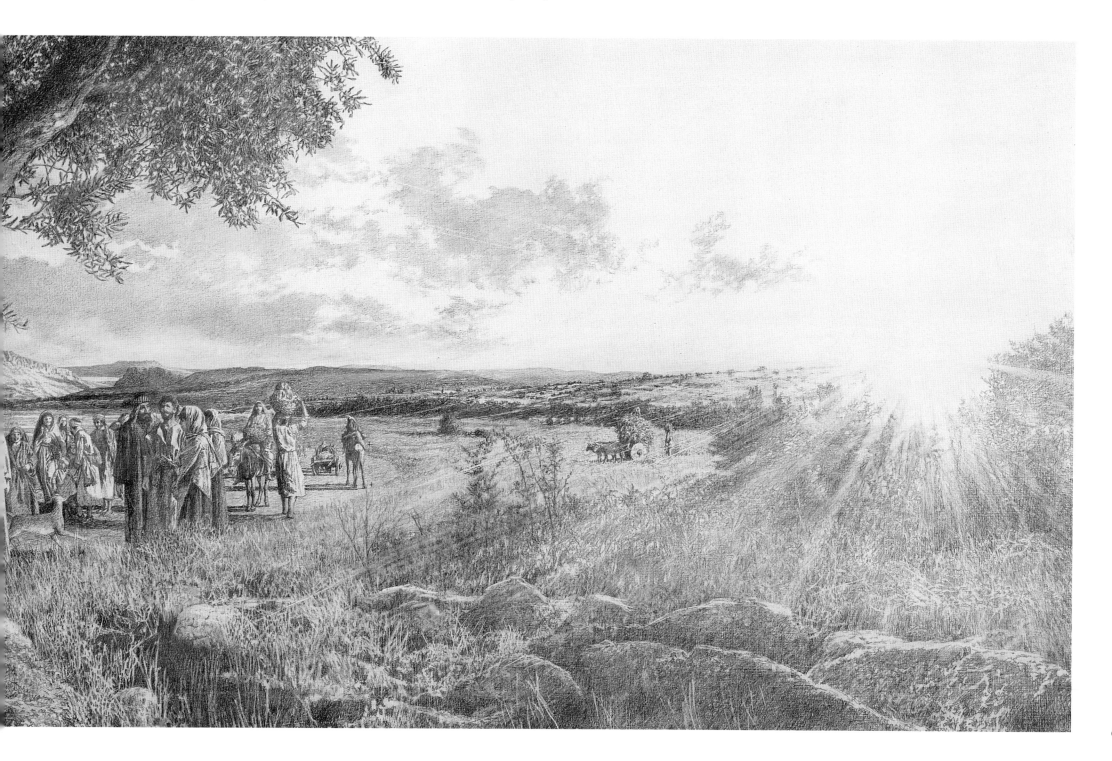

The Transfiguration

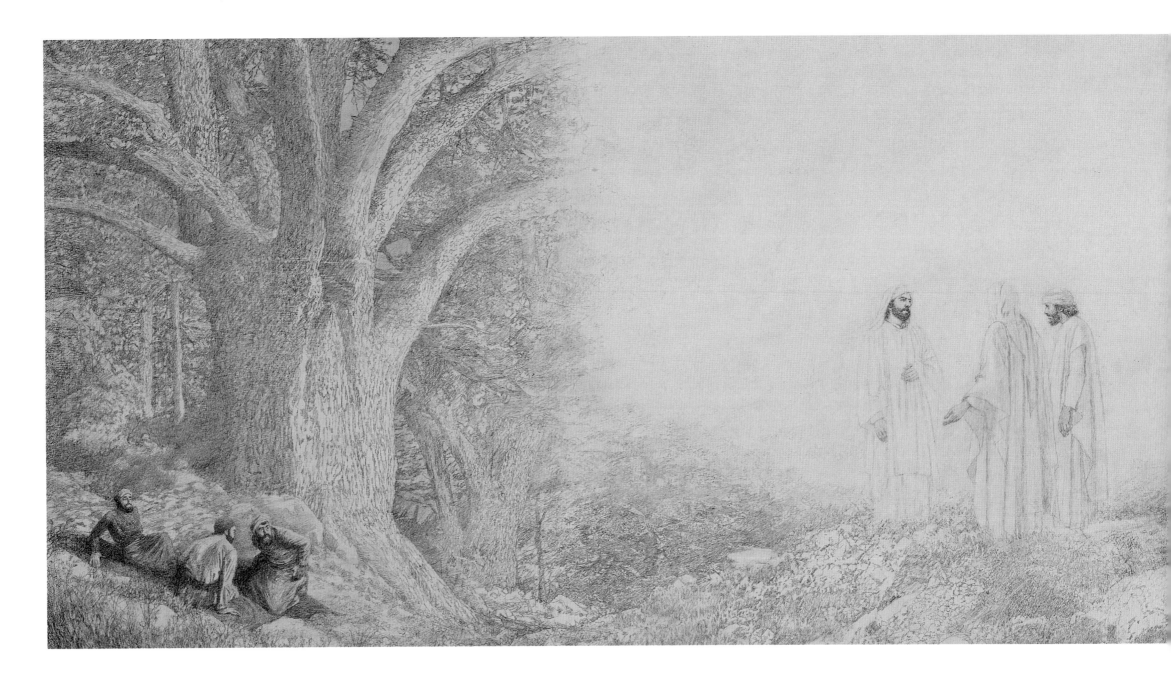

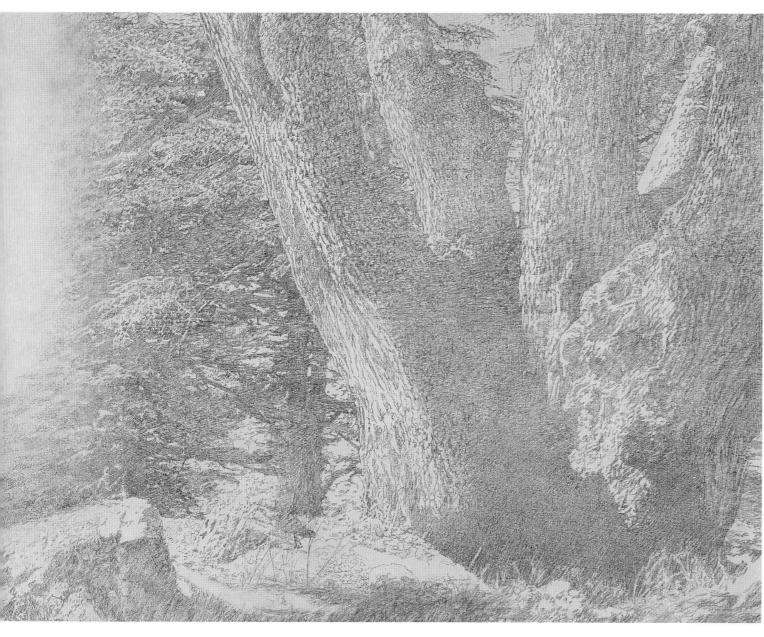

Jesus took Peter, James, and John up into a high mountain near Caesarea Philippi to pray, and there He was transfigured before them.

It seemed best to set this scene on the slopes of Mt. Hermon, in a grove of giant Cedars of Lebanon which still grow there.

On the same mountain where Satan tempted Jesus with the kingdoms of the world on his ugly terms, the Heavenly Father glorified the Son with a preview of His kingly glory when Jesus will rule, not only the kingdoms of this world, but also the entire universe.

MATTHEW 17:1–8; MARK 9:2–8; LUKE 9:28–36

Jesus Visits Martha, Mary, and Lazarus

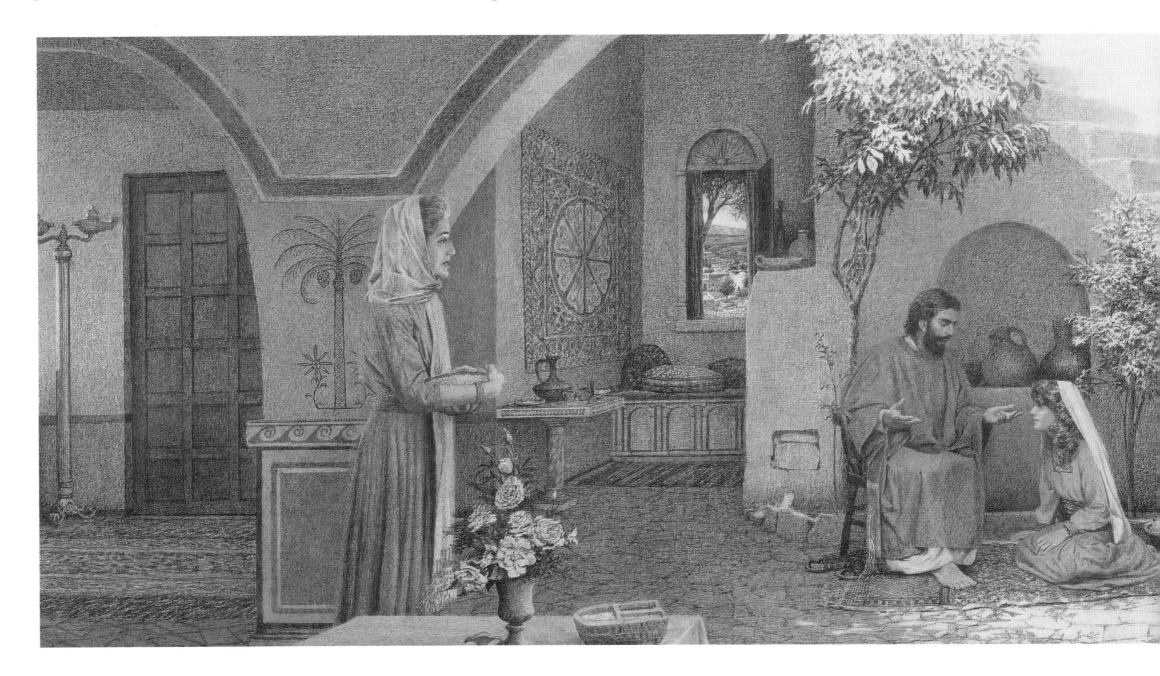

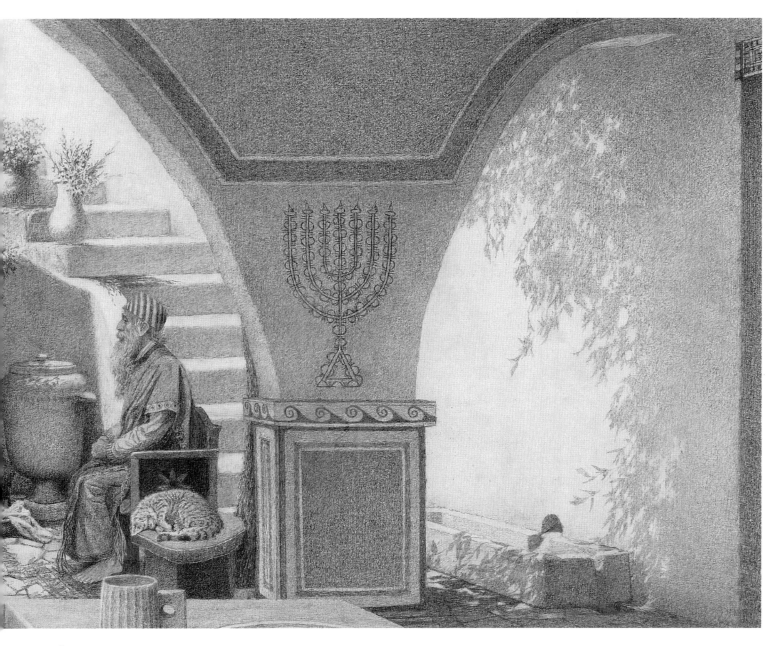

Just imagine Jesus coming to visit you, and you have some idea of what it meant to His friends in Bethany when He stopped to see them on His way to Jerusalem. What precious moments these were!

Martha surely loved Jesus very much, and in her own way she wanted to show this. The trouble was that she wanted Mary to show her love for Him in the same way. When Martha complained that Mary was not helping her prepare the meal, Jesus not only defended Mary, but even said her way was better.

Mary's way allowed Jesus to enjoy true fellowship with her.

They both understood that the food could wait.

LUKE 10:38–42

"Lazarus, Come Forth!"

When Jesus learned that Lazarus was gravely ill, He waited four days before going to him. He wanted in this way to increase the faith of the disciples by raising Lazarus from the dead.

Jesus brought glory to God when He called life back into the dead body of His friend. He also brought a special kind of joy to the hearts of all who loved Lazarus.

What a Friend we have in Jesus!

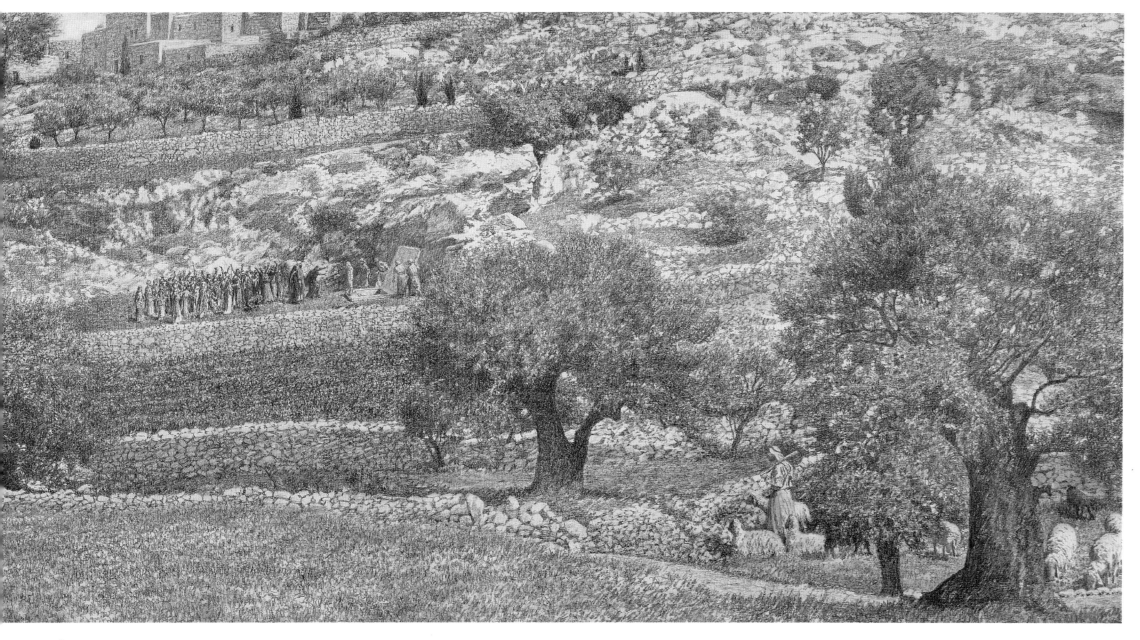

JOHN 11:1-44

69

The Grateful Leper

When Jesus began His last journey to Jerusalem, He came to a village on the border between Samaria and Galilee. There He was greeted by ten lepers who stood at their distance and called out, *"Jesus, Master, have pity on us!"* When He saw them He called back, *"Go, show yourselves to the priests."* And as they started on their way, they were healed!

Nine of them continued on their journey, rejoicing in their good fortune. Only one, a Samaritan, turned back to thank the greatest Priest of them all.

John the faithful stands in awe next to Jesus. Judas the ungrateful looks down on the altogether grateful one. And Jesus looks with compassionate grace upon the man who not only remembered to give the glory to God, but whose faith, said Jesus, had made him whole.

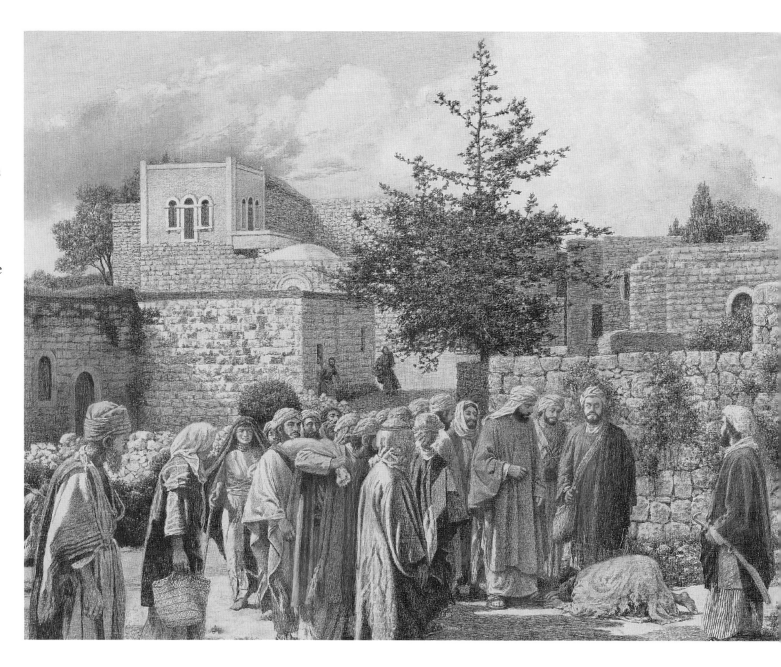

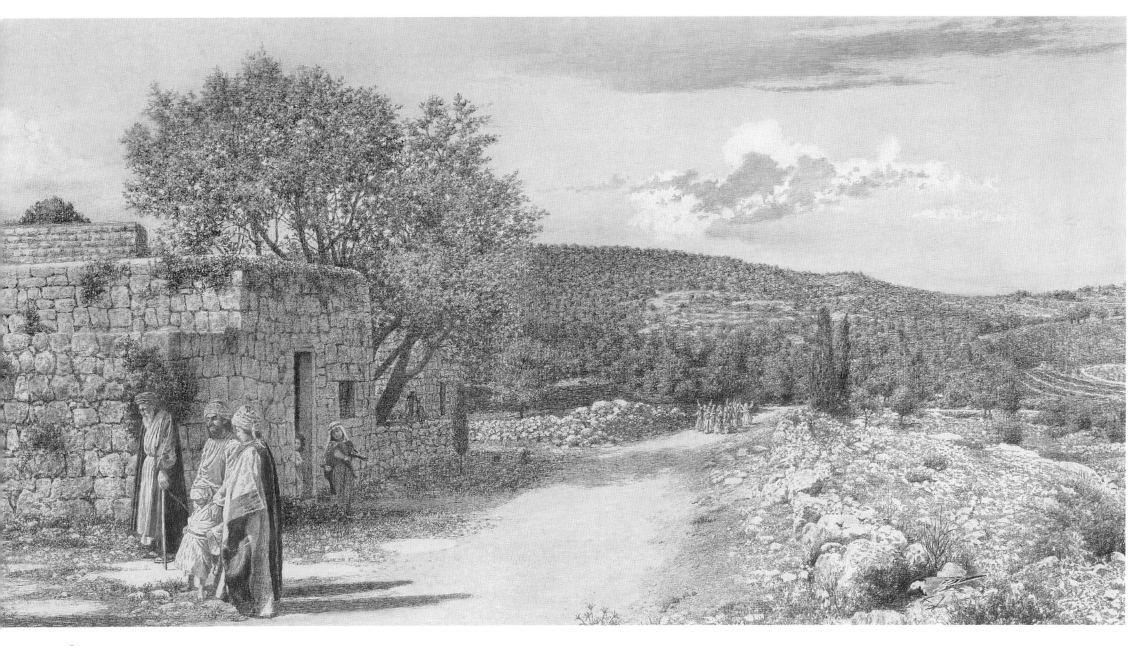

LUKE 17:11–19

71

Blessing the Little Children

Near the close of His ministry, Jesus left Galilee and came to a land beyond the Jordan—the province of Perea. People brought their little children to Jesus, hoping He would bless them. But the disciples rebuked

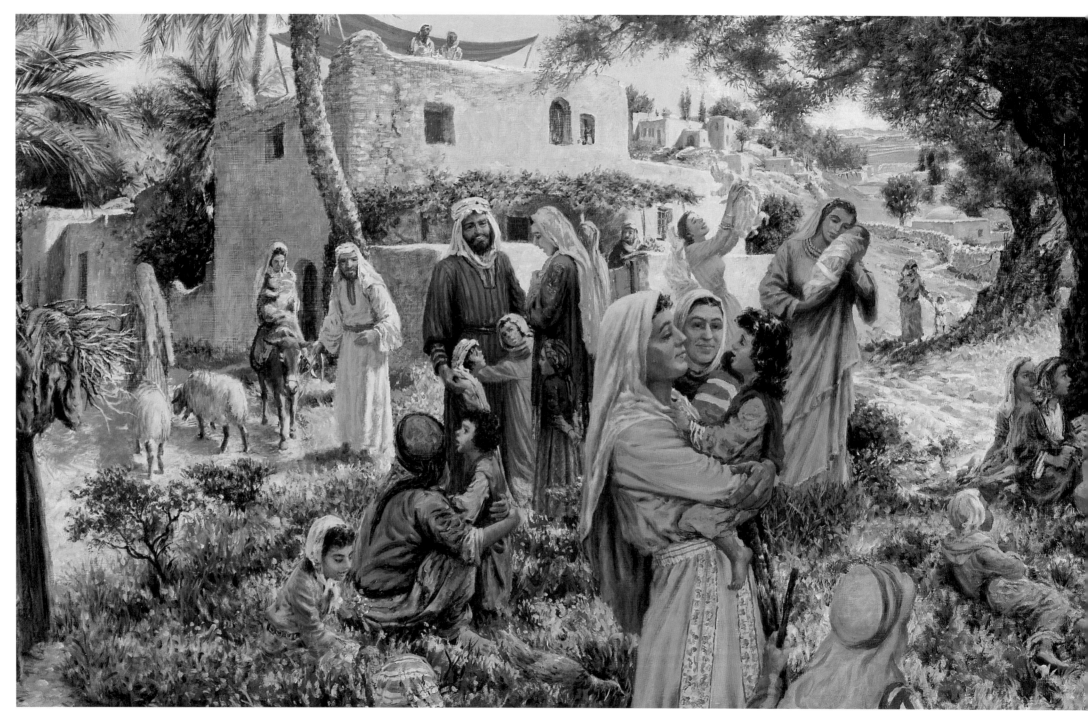

those who brought the little ones. Then Jesus said to the disciples, *"Let the little children come to Me, and do not hinder them, for the Kingdom of God belongs to such as these."*

With this Jesus not only taught the disciples a lesson in kindness, but also showed them the sort of faith that leads to heaven.

MATTHEW 19:13–15
MARK 10:13–16
LUKE 18:15–17

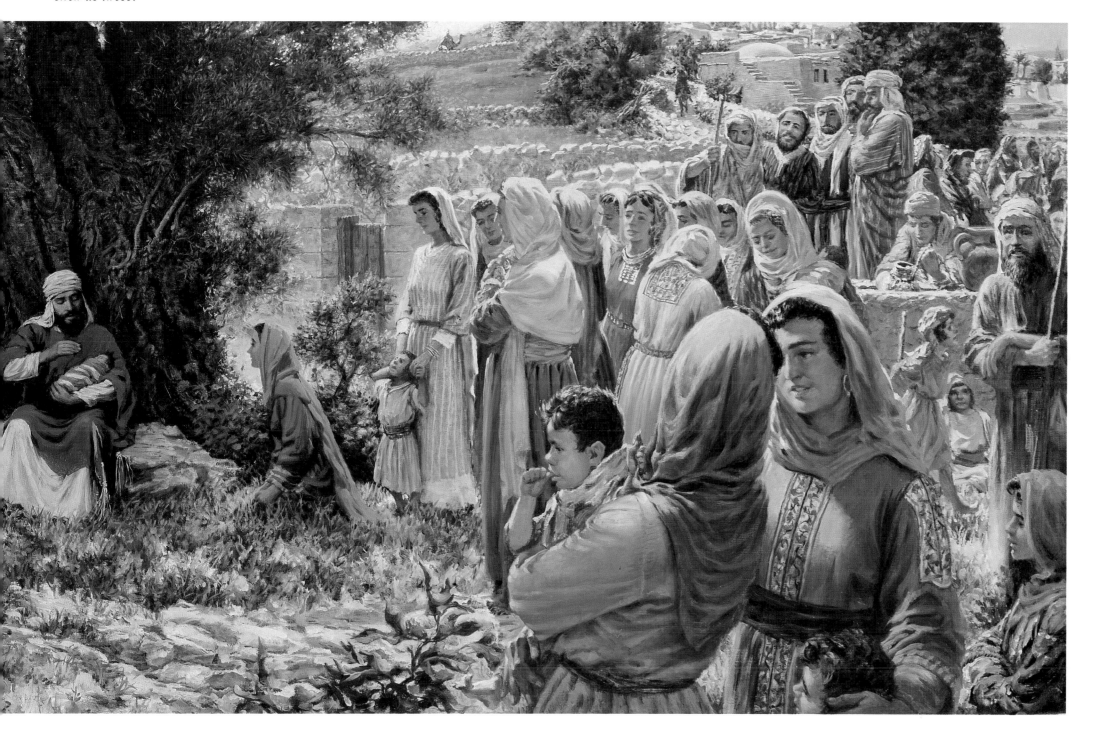

The Rich Young Ruler

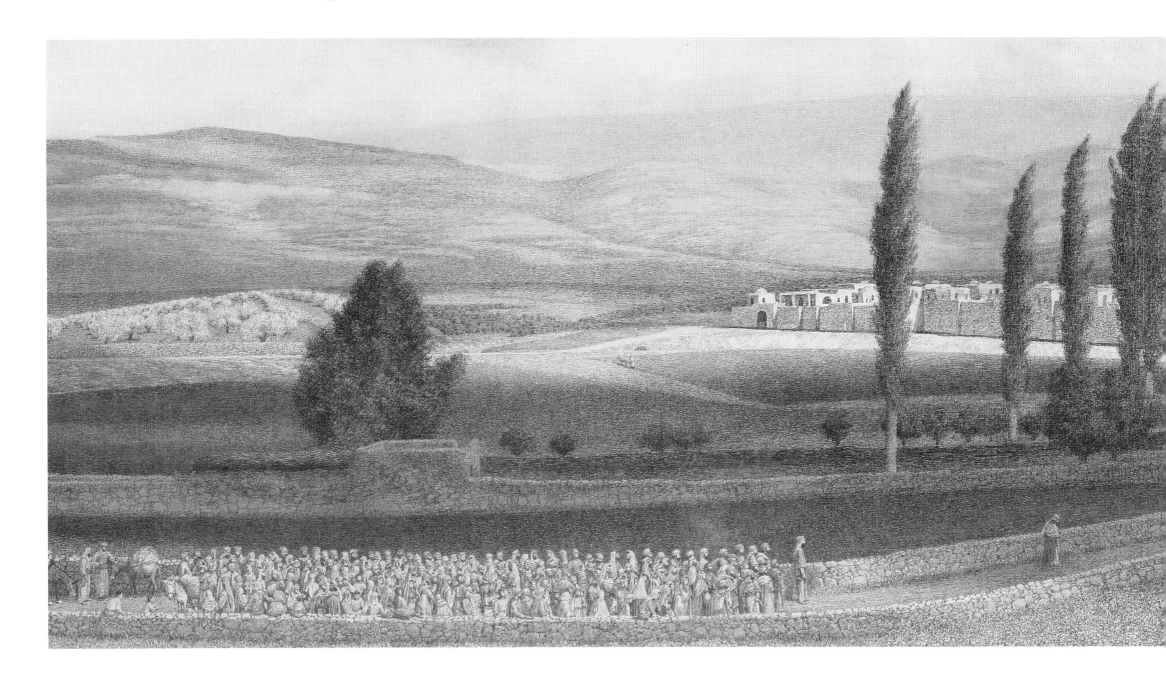

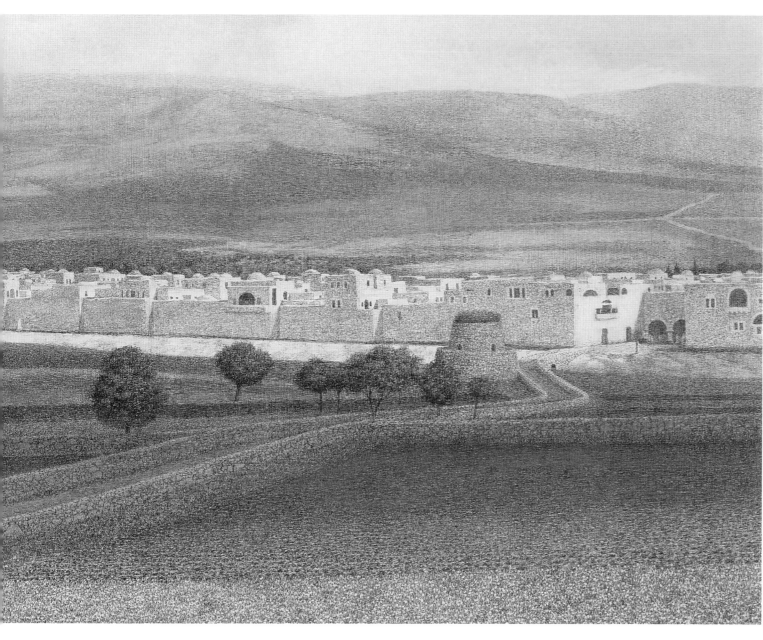

It was in Perea that Jesus was greeted by a young man who came running up to Him, knelt, and asked, *"Good Teacher, what must I do to inherit eternal life?"*

Jesus answered, "Keep the Law."

The young man said, "I have done this since I was a child!"

Jesus, looking on him, loved him and said, *"You still lack one thing. Sell everything you have and give to the poor, and you will have treasure in heaven. Then come, follow Me."*

The young man's countenance fell at His answer, for he had many possessions.

A cloud has cast a great shadow as the rich young man turns away in his sorrow. However, the sun still shines brightly on the town to which he is returning, for there he may eventually see the light that Jesus has just offered him.

For Jesus, looking on him, loved him.

MATTHEW 19:16–26; MARK 10:17–27; LUKE 18:18–27

Jesus Visits Zaccbaeus

In Jericho, a rich resort town in Herod's time, a small, rich man with a small, greedy heart had to climb a sycamore tree to catch a glimpse of Jesus. To Zacchaeus's great surprise, Jesus saw him and invited Himself to a visit in his home.

After being in the presence of Jesus for only a short time, Zacchaeus not only promised to repay four times over anyone he had cheated, but also to give half of his fortune to the poor.

In the company of Jesus, that rich man grew richer; that short man grew tall; and his greedy heart grew generous.

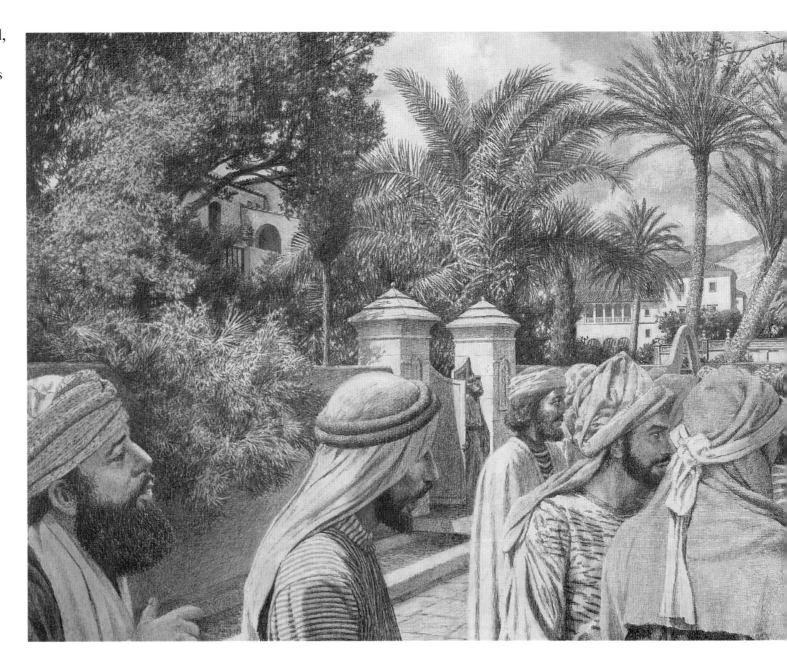

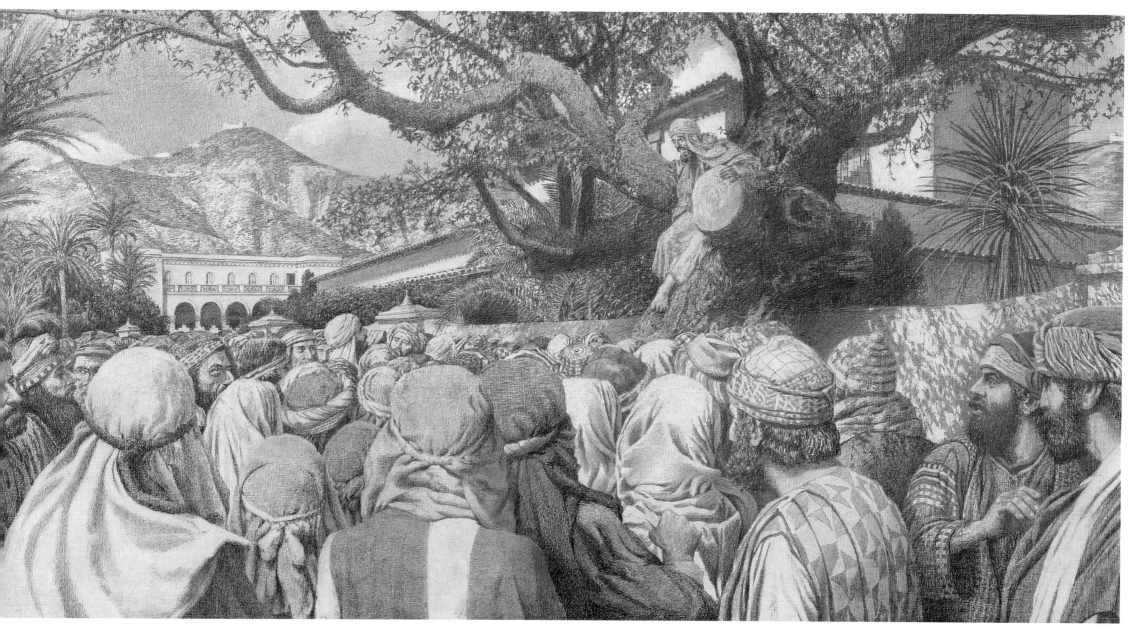

LUKE 19:1-10

The Triumphal Entry

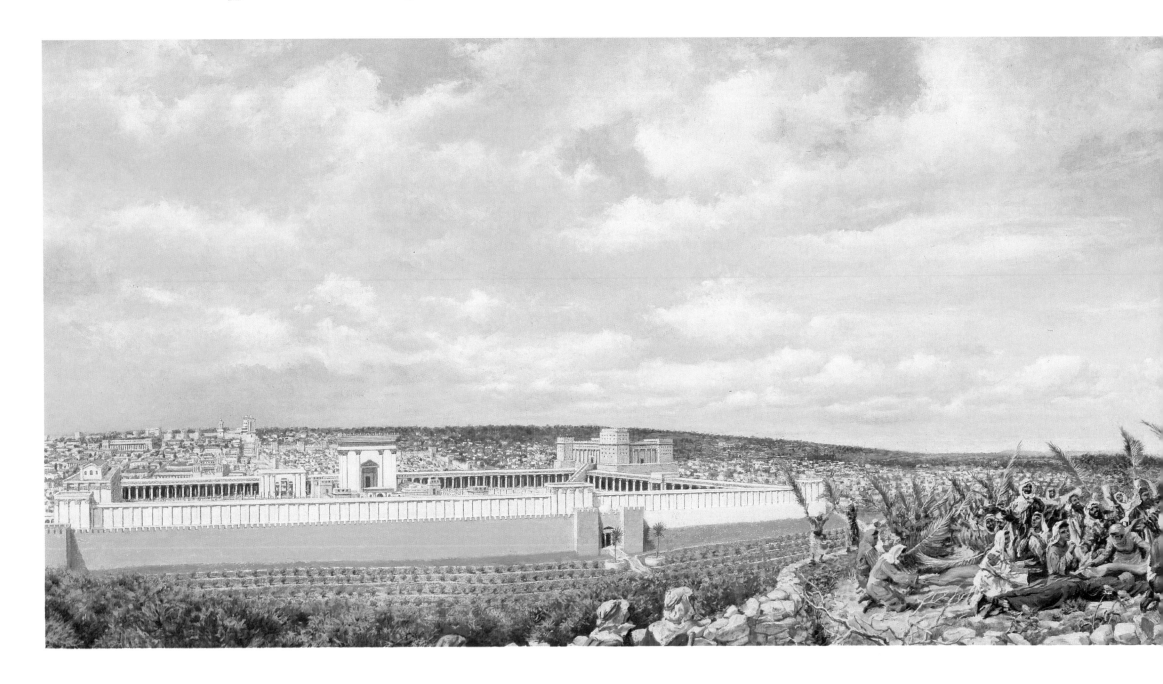

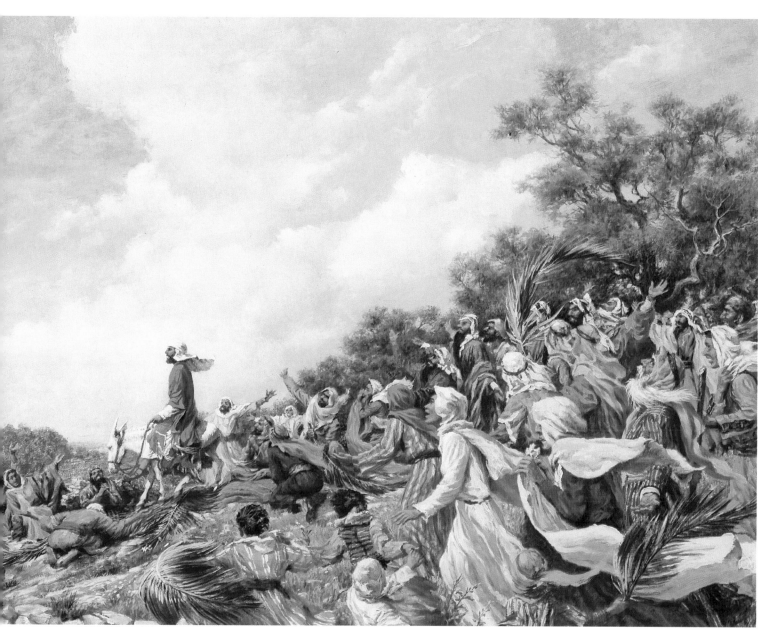

There was more of heaven than earth in the air that glorious day when the Holy Spirit swept across the souls of the multitude. The bliss that filled their worshipful hearts is reflected in the billowing clouds, reminding us of the majestic glory of God presiding over the event.

They had waited long for their Messiah, and now He was riding forth to deliver them—just as God had promised! What more could Messiah do than what He had already done? They had watched as He healed the sick, made the blind to see, and the lame to walk. Even the dead arose at His command. He had fed the hungry, calmed the stormy sea, and even walked upon its waters. He taught them all—even the chief men of Judea—with divine authority as could no other.

Praise and worship had never been so exhilarating as it was on that day.

They that followed shouted, *"Hosanna! Blessed is He who comes in the name of the Lord! Blessed is the coming kingdom of our father David! Hosanna in the highest!"*

MATTHEW 21:1–11; MARK 11:1–10; LUKE 19:29–38; JOHN 12:12–15

The Widow's Mites

Jesus and His disciples are in that section of the Temple called The Court of the Women. Here, along one of the walls, were thirteen stone chests shaped like inverted trumpets.

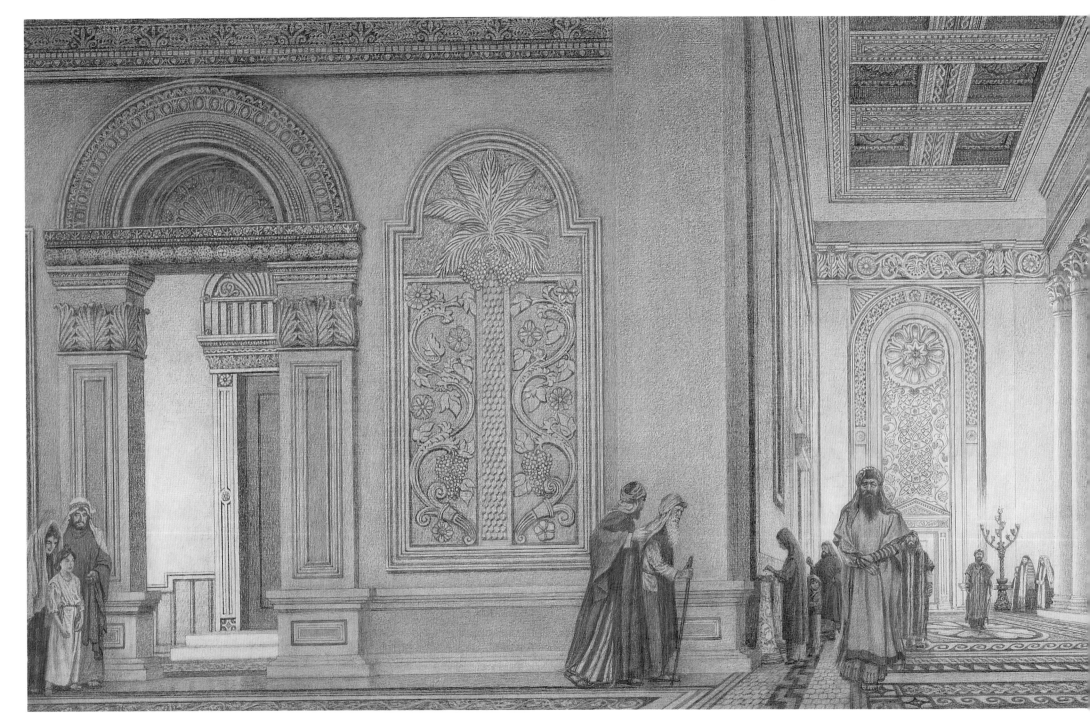

The Temple may have intimidated some by its great glory, but not this woman! She was giving to God, and that was all that mattered. The widow believed God Himself was in this place, and indeed He was—not only in the Holy of Holies—but just a few feet from where she stood.

And He was smiling on her.

MARK 12:41–44; LUKE 21:1–4

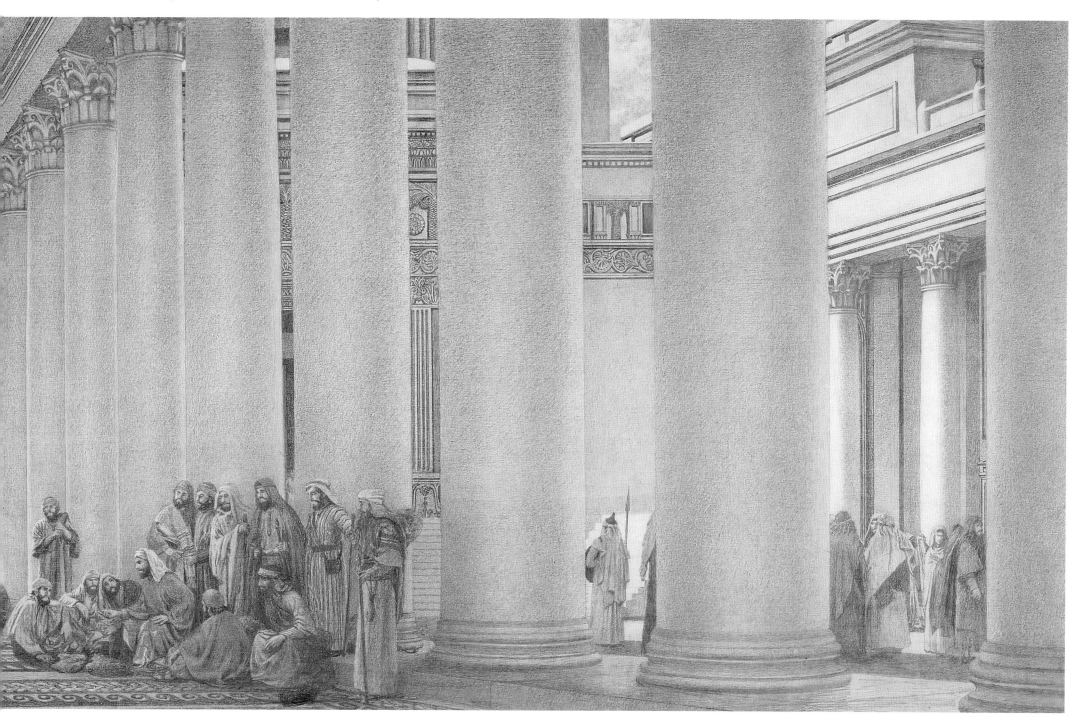

The Olivet Discourse

A short while before they arrived on the Mount of Olives to rest, Jesus and His disciples visited the Temple. As they were leaving, the disciples boasted about the beauty of the buildings. The startling response Jesus gave them needed some explanation. So, once they reached the Mount, Peter, James, John, and Andrew asked privately when the destruction of the Temple would take place. To set the mood for Jesus' answer, the dramatic light and swirling clouds symbolize the shattering judgment to come.

The disciples must have been stunned. Their Messiah, who was expected to deliver the people and expand His peaceful kingdom to include all the nations of the earth, was suddenly issuing a totally unexpected proclamation: the complete destruction of Jerusalem and the scattering of the Jews to the ends of the earth!

How could this possibly be? Why did the Messiah come at all if it was to bring such a devastating and heartbreaking message?

This was not the first time He had confused them. The Bible states that Jesus told them many times before about His impending death at Jerusalem, but they did not understand because the truth was hidden from them. Now He was telling them again. The time had finally come—in just two days Jesus would die on a cross!

Can it be any wonder that the disciples were completely shocked and dismayed from that time until after the Resurrection? Yet His very presence was enough to keep them together, until the garden of Gethsemane.

This was a sad, sad day, and the gloom would not lift until the first day of the week.

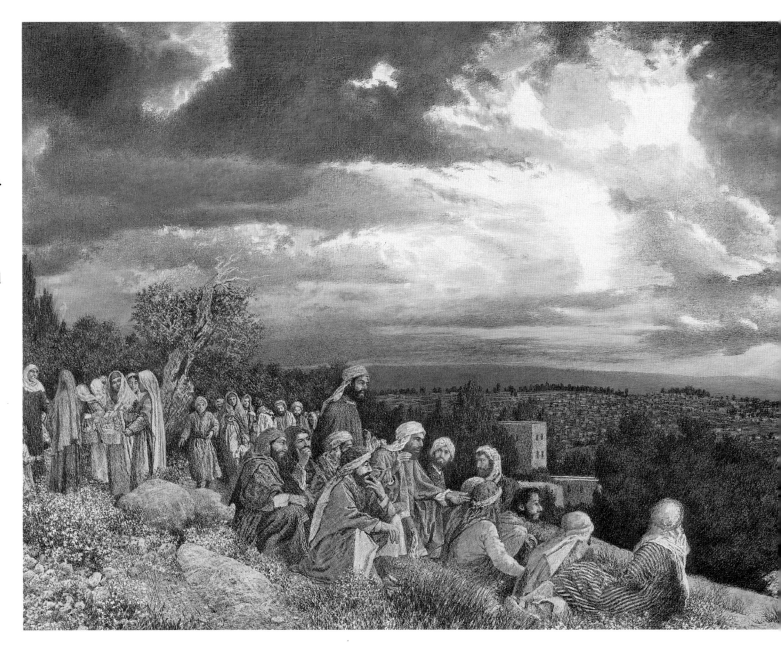

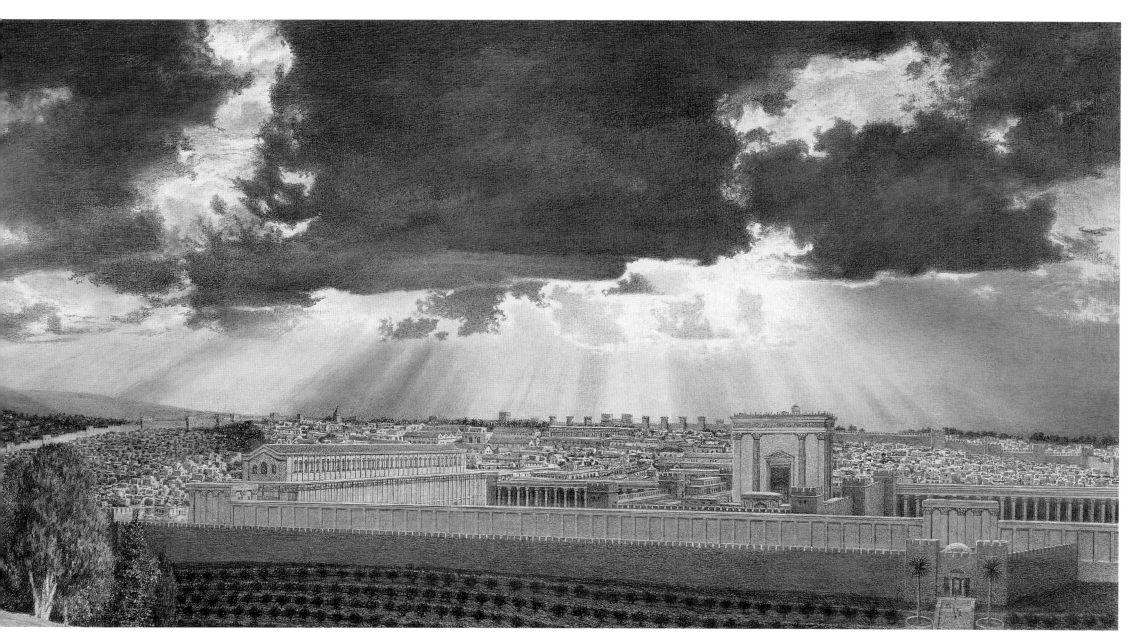

MATTHEW 24:1–42; MATTHEW 26:1-2; MARK 13; LUKE 21:5–36

83

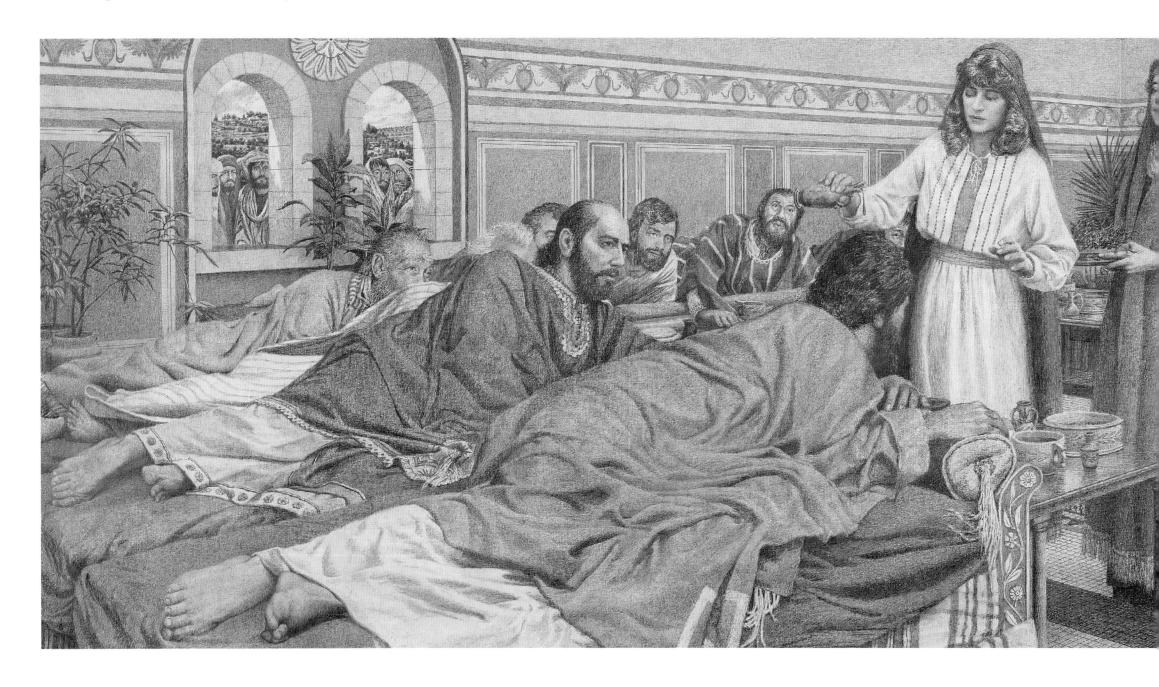

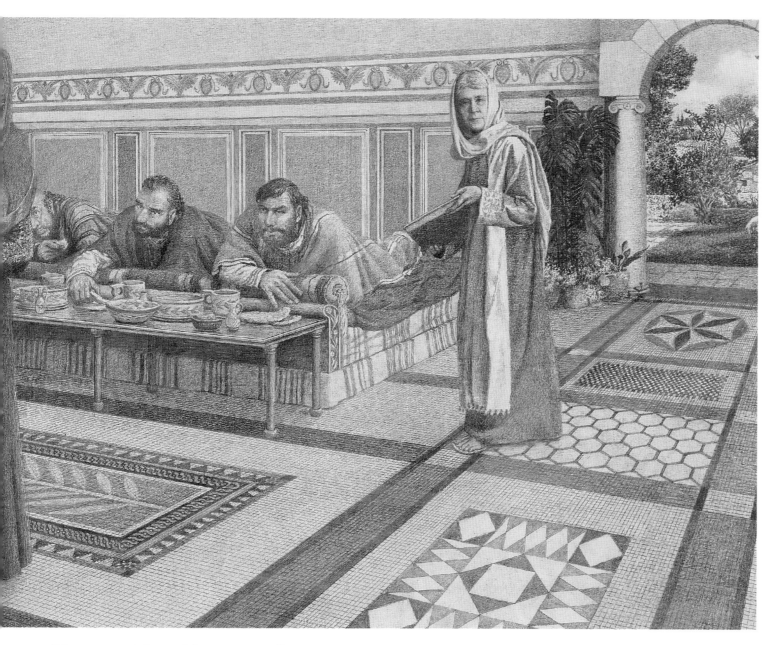

It seems that only one person had ears to hear the most important message Jesus brought to earth: He had come to die for the sins of Jew and Gentile alike and on the third day would rise from the dead to take His place as King of Kings and Lord of Lords.

When Mary anointed Jesus with pure and costly nard, the rude disciples actually became angry at her and complained that she hadn't sold the perfume and given the money to the poor. Jesus rebuked them again for their blindness and hardness of heart with these words:

"Leave her alone. Why are you bothering her? She has done a beautiful thing to Me. . . . She poured perfume on My body beforehand to prepare for My burial. I tell you the truth, wherever the gospel is preached throughout the world, what she has done will also be told, in memory of her."

Matthew 26:6–13; Mark 14:3–9; John 12:1–8

Jesus Washes the Disciples' Feet

The sacrament of the bread and wine which was established by Jesus at the Last Supper was, of course, the most important event of the evening. Yet a close second was the symbolic act of washing the disciples' feet, even those of Judas, who Jesus knew would betray Him.

To the very end, Jesus did everything He could to show Judas that He loved him also. In this He set the example of caring for our enemies.

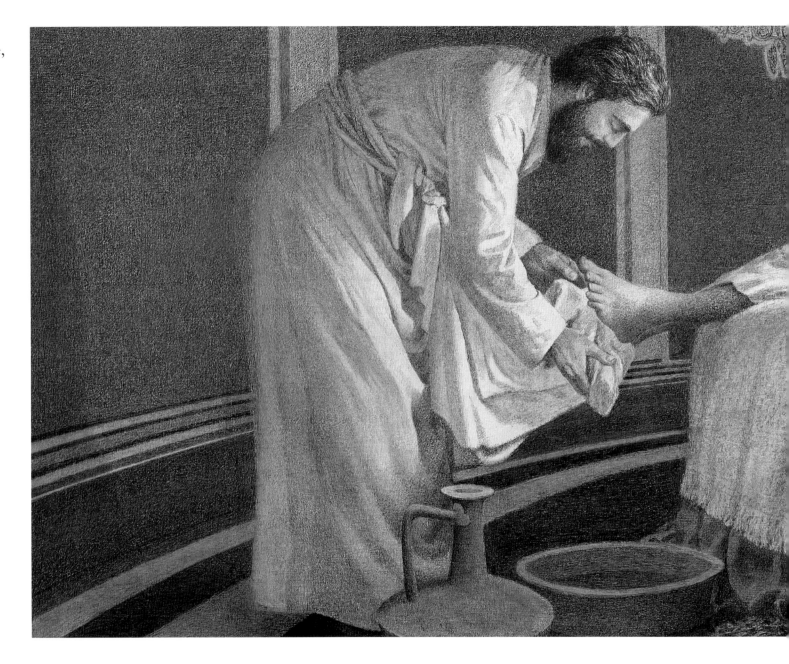

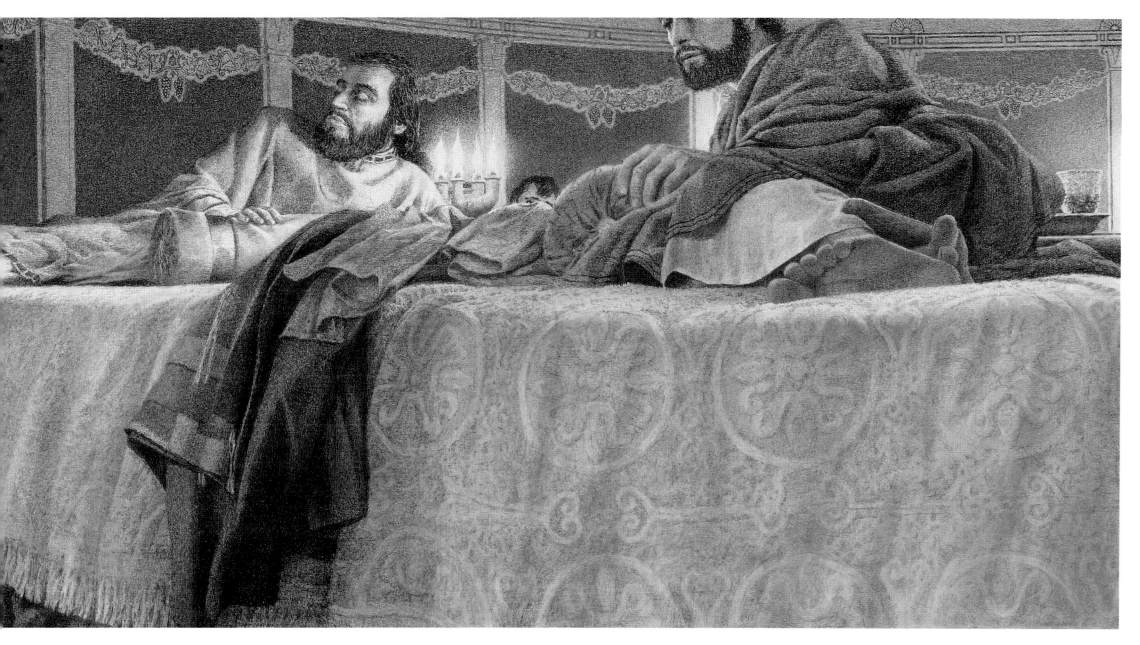

JOHN 13:1–5, 12–15

The Bread and the Wine

In the large upper room where Jesus and the disciples shared their last supper together—where He presided as Host—there must have been an unusual elegance. The Greek word for large is *megas*, which includes in its meaning: "great," "high," and "exceeding," and would seem to indicate some kind of banquet hall.

It was a fitting place since there Jesus said to them, *"I will not drink of this fruit of the vine from now on until that day when I drink it anew with you in My Father's kingdom."* A banquet hall of this type would serve as a splendid symbol of that transcendent banquet hall in the realm of Glory.

The Lord Jesus served the wine to His disciples, beginning with John, who occupied the place of honor. Could it be because John would be the only disciple to stay with Jesus throughout His time of suffering?

Though Judas's place at the table is vacant, notice that in the plate from which the bread was served one piece remains.

Jesus had lovingly provided for Judas once again.

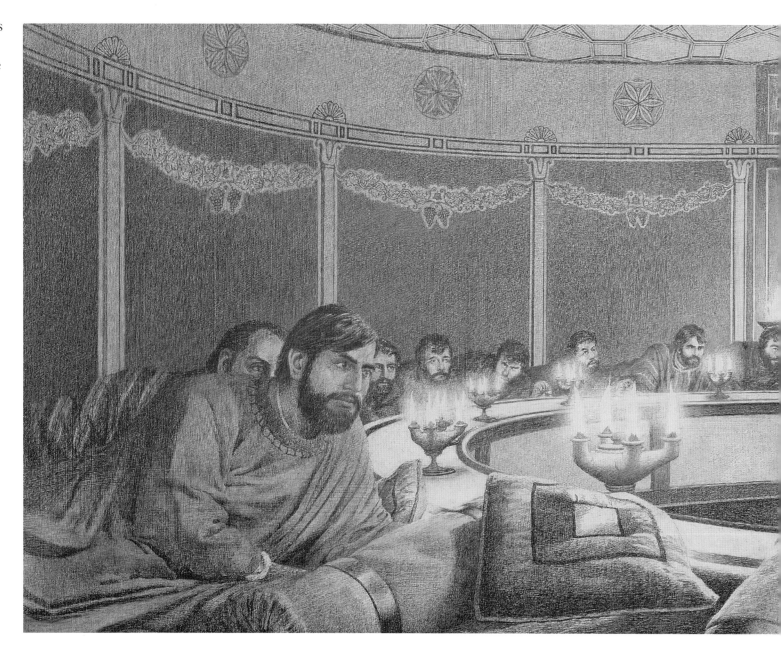

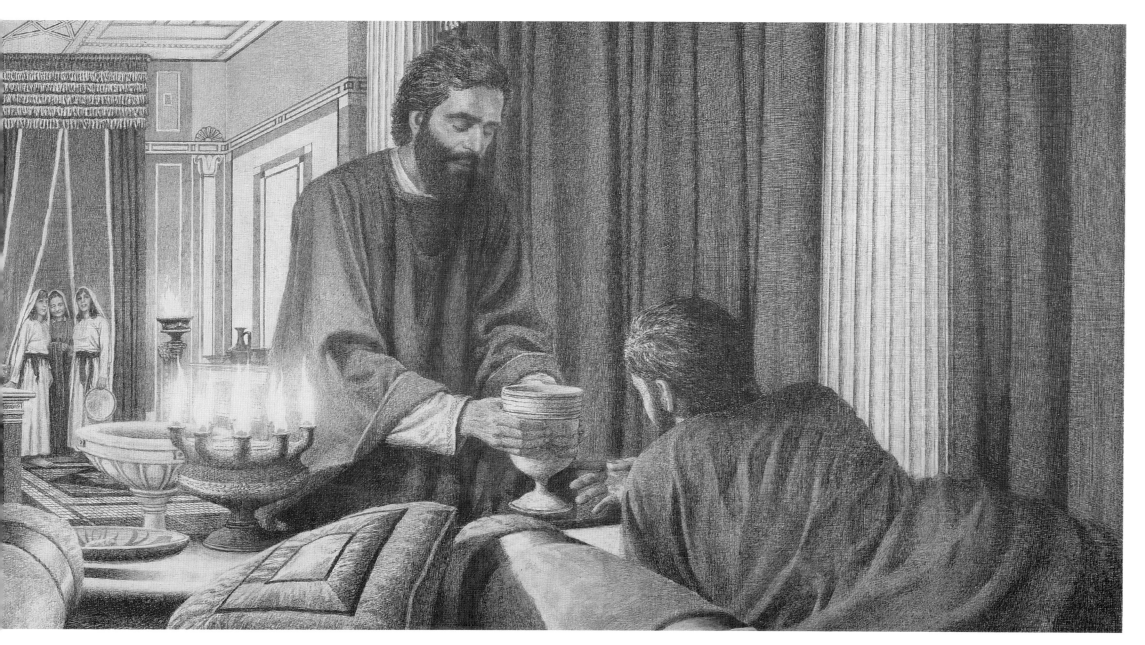

MATTHEW 26:26–29; MARK 14:22–25; LUKE 22:17–20

89

Gethsemane

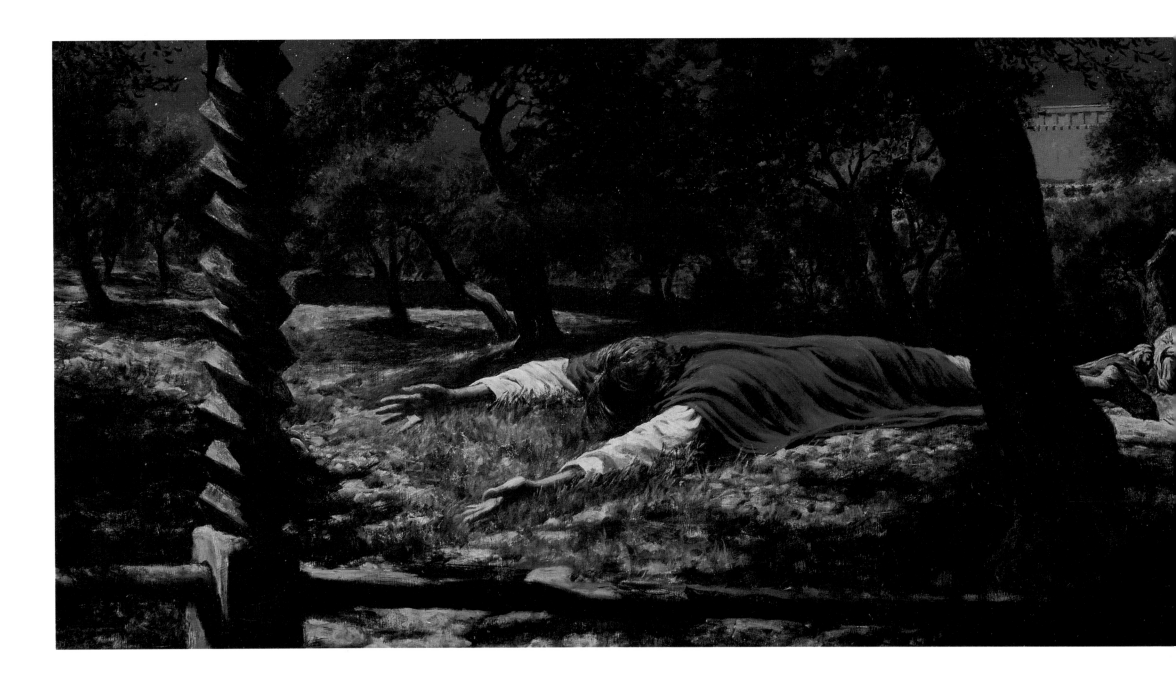

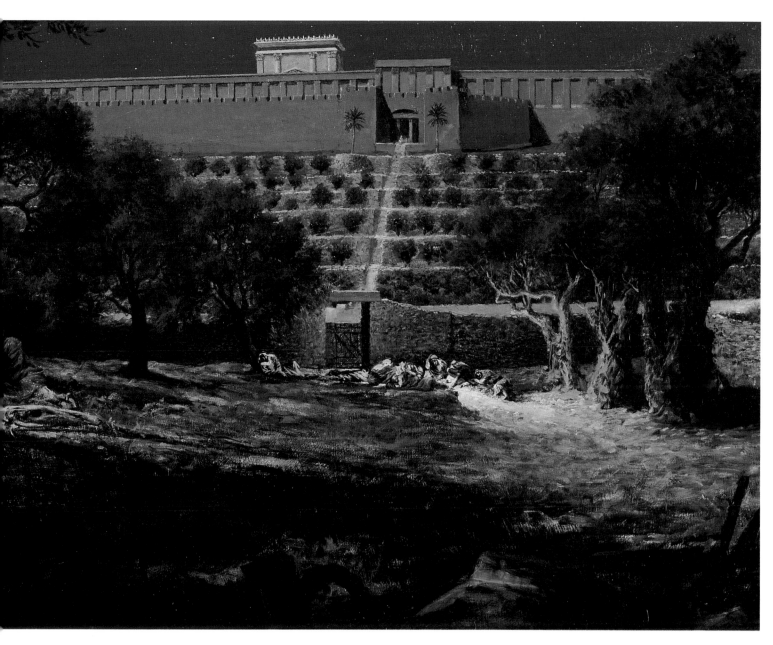

After the poignant experience of the Last Supper, Jesus said to the disciples, *"I will not speak with you much longer, for the prince of this world is coming. He has no hold on Me, but the world must learn that I love the Father and that I do exactly what My Father has commanded Me. Come now; let us leave."*

Then they went out to the garden of Gethsemane. Leaving the other disciples inside the gate, Jesus took with Him Peter, James, and John a short distance away. He began to be greatly amazed and sorely troubled and He said to them, *"My soul is overwhelmed with sorrow to the point of death. Stay here and keep watch."* Then He went on a little further and fell on His face in such overwhelming agony that *"His sweat was like drops of blood falling to the ground."*

Jesus' life was slowly being pressured out of Him. It was as if the Father had sent Jesus to Satan, who seemed to have power to put Him to death before He could reach the cross. If Satan could have forced Jesus to use His own will to resist, he would have succeeded.

But Jesus had not come to do His own will. He had come to do the will of His Father. He would not oppose the Father, even in the face of premature death.

And so, in this hour of trial, He showed the world that He loved the Father more than He loved Himself when He cried out, *"Father, if You are willing, take this cup from Me; yet not My will, but Yours be done."*

With this painful cry of utter humility in the hour of His greatest agony thus far, Jesus gave the world a most precious gift: the perfect plea in life's darkest moments.

MATTHEW 26:36–44; MARK 14:32–36; LUKE 22:39–46; JOHN 14:30–31; JOHN 18:1

The Judas Kiss

It seems that Satan planned to have Judas betray Jesus into the hands of the Sanhedrin. Ordinarily, this would have resulted in death by stoning. But Jesus had repeatedly made it clear that He would be crucified and that, even then, no one would take His life—He would lay it down Himself.

When the Sanhedrin decided to try Jesus before Pilate, Satan's plans were foiled.

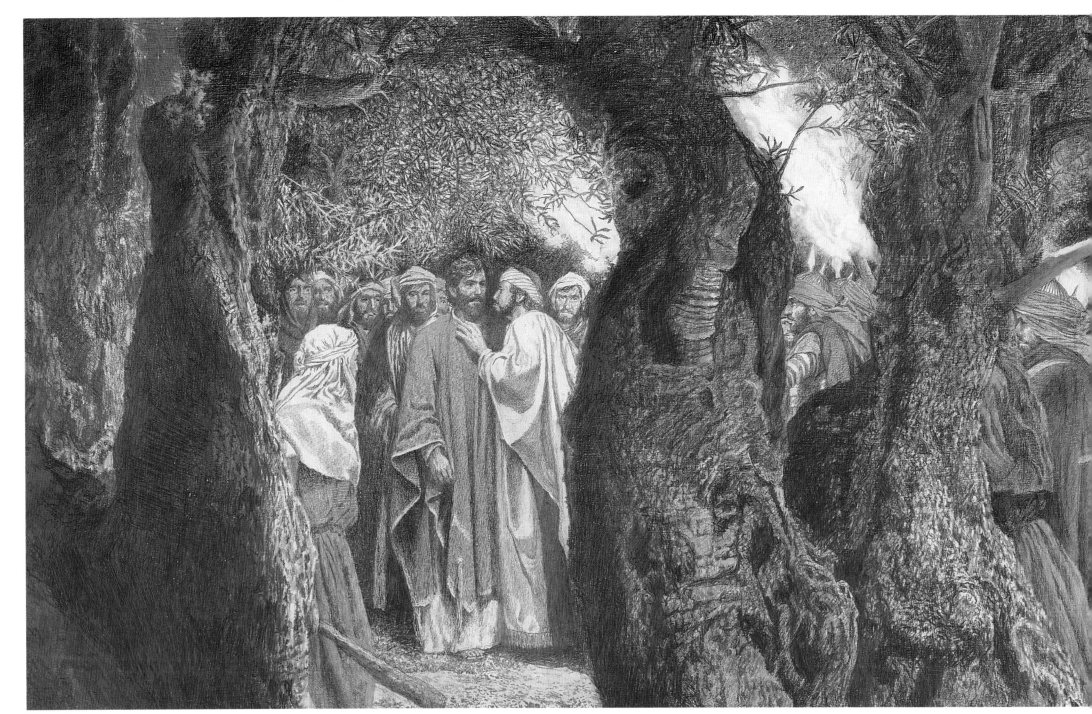

The author of confusion and his willing slave drank
deeply from their own cup. And lost.

MATTHEW 26:47–50; MARK 14:43–46; LUKE 22:47–48; JOHN 18:2–5

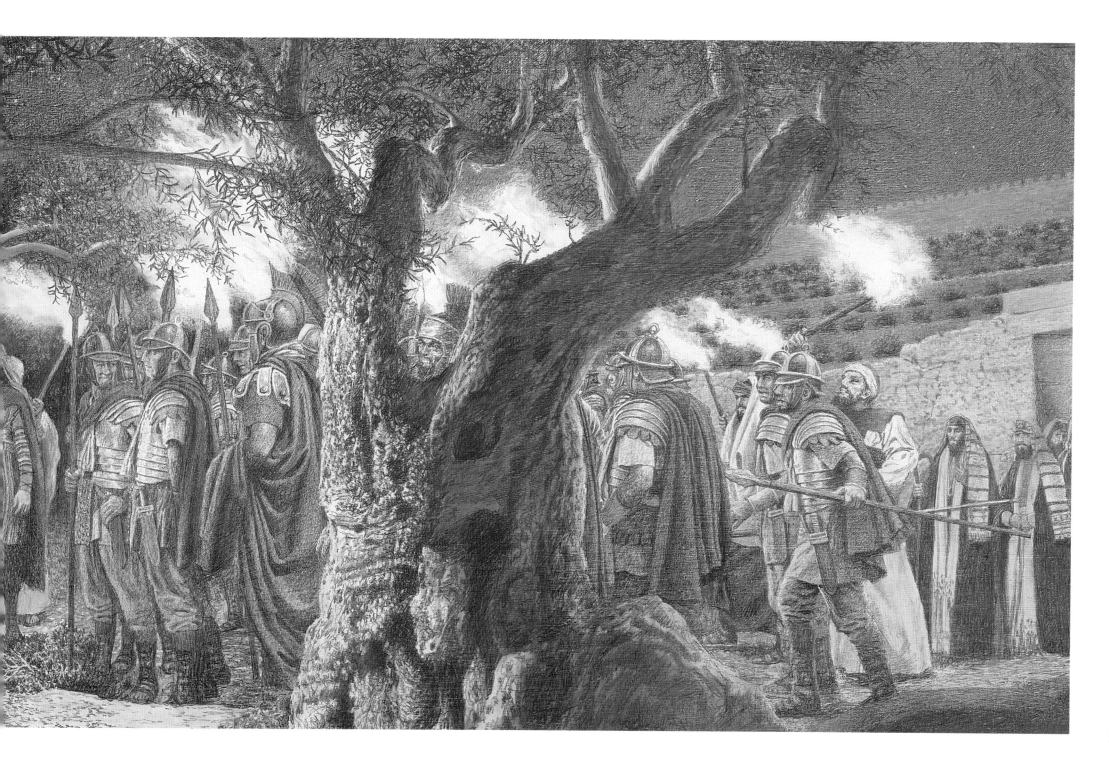

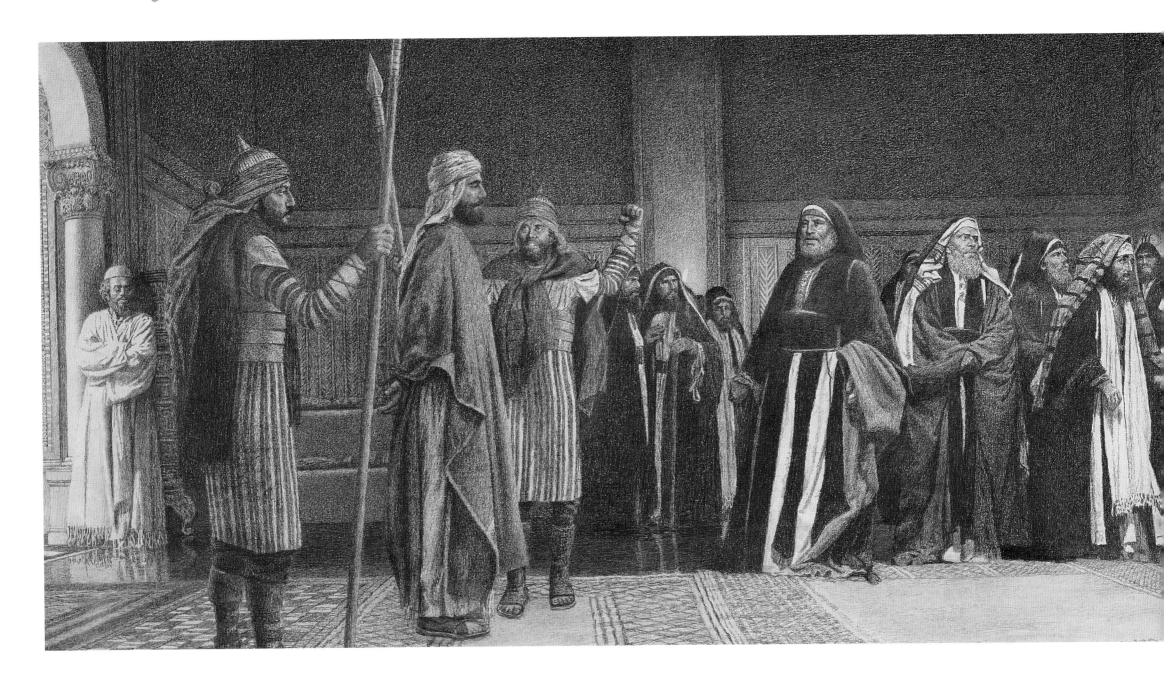

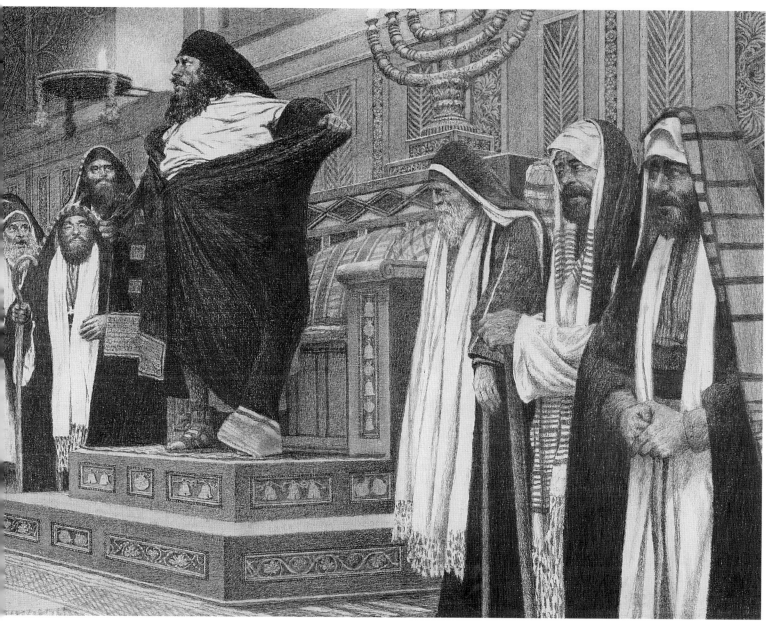

As Jesus stands trial before the Sanhedrin, Nicodemus and Joseph of Arimathea show their disapproval: Joseph looks with sympathy at Jesus, and Nicodemus looks sorrowfully at the Chief Priest. In such an emotionally charged atmosphere, it is difficult to imagine anyone sitting sedately in their places.

Jesus gave them exactly what they wanted. They asked Him, *"Are You then the Son of God?"* He answered, *"You are right in saying I am."*

When they heard His answer, they said, *"Why do we need any more testimony? We have heard it from His own lips."*

Men condemned God for blasphemy!

MARK 14:60–63; LUKE 22:66–71

95

Trial by Pilate

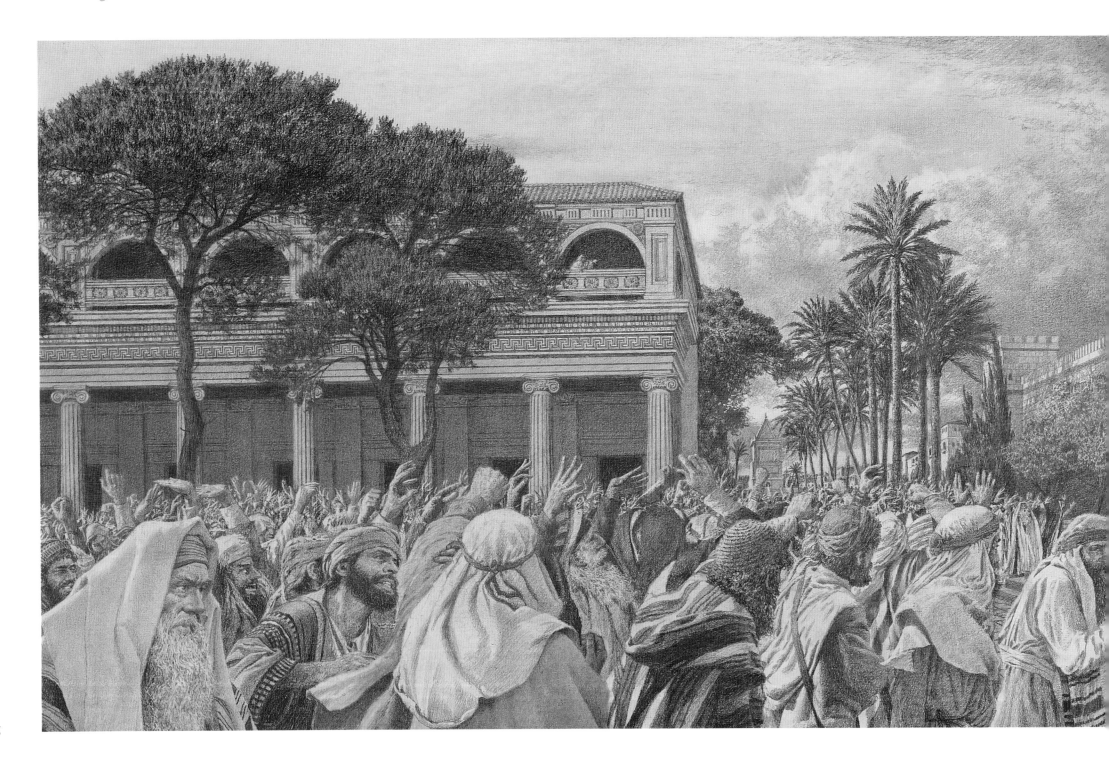

The crowd, in hysterical fury, insisted with loud
voices that Pilate have Jesus crucified.
 And their voices prevailed.

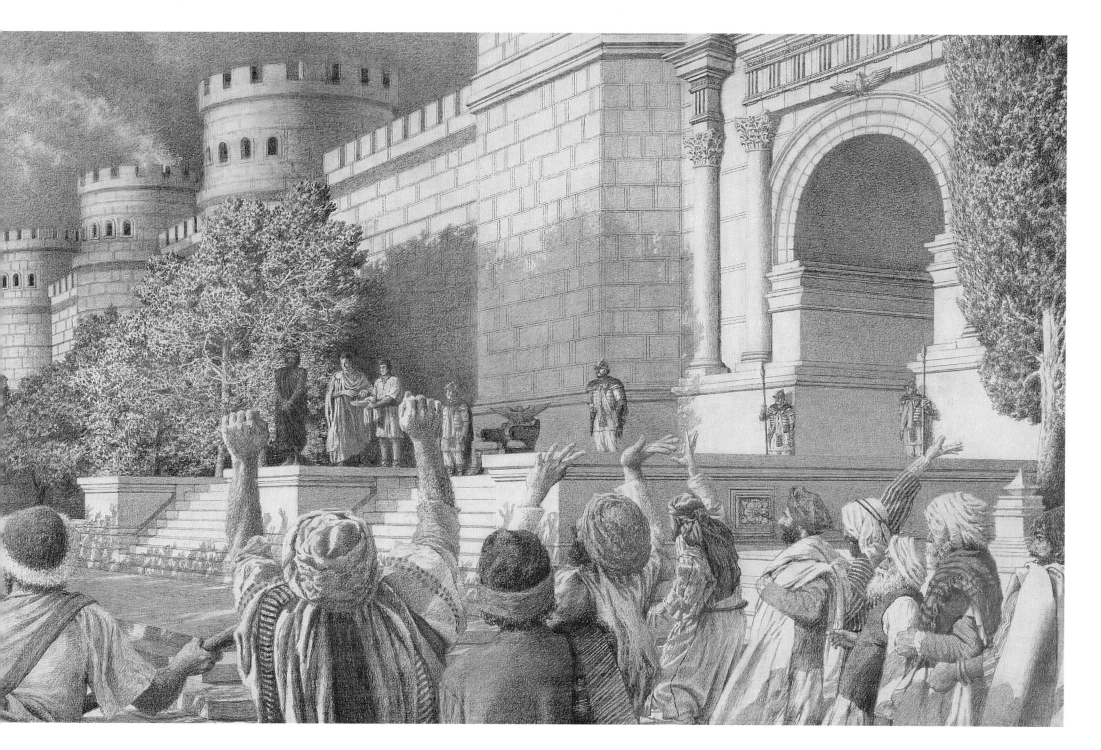

The Soldiers Mock Jesus

Pilate's soldiers took Jesus into the courtyard and surrounded Him. They stripped off His clothes, laid a purple robe on Him, put on His head a crown of thorns, and placed a reed as a scepter in His right hand. Then they knelt before Him and mocked Him saying, *"Hail, King of the Jews!"* And they spat on Jesus and took the reed and hit Him on the head with it.

"He was oppressed and afflicted, yet He did not open His mouth."

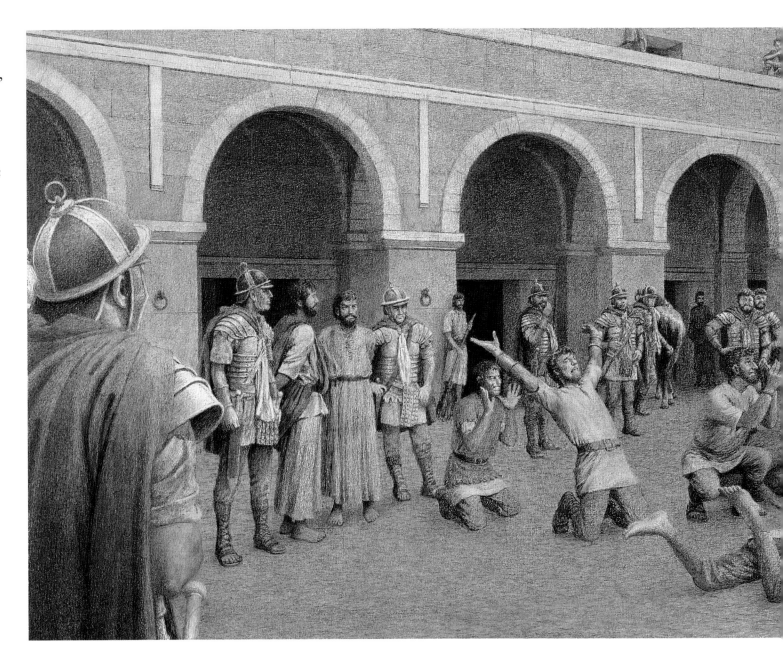

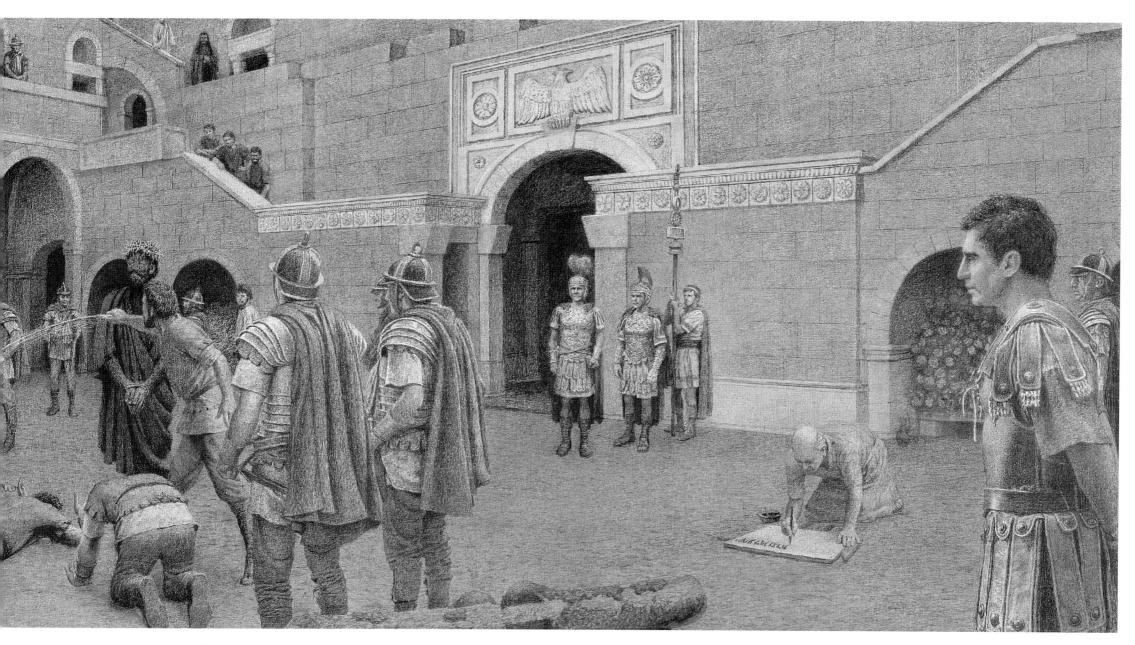

MATTHEW 27:27–30; MARK 15:16–19; ISAIAH 53:7

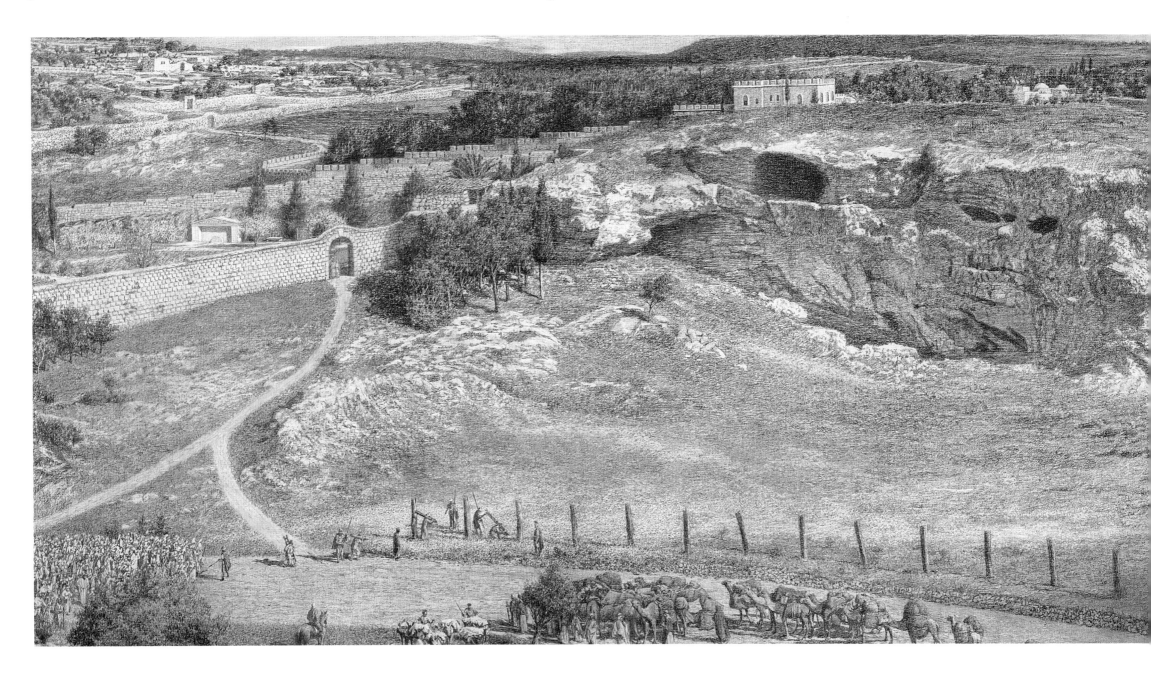

As the procession of soldiers and the three men to be crucified came out of the palace courtyard, they compelled a man from Cyrene, named Simon, to carry the crossbeam for Jesus. It could be that the centurion in command, who later at the cross glorified God when he said, "Truly, this man was the Son of God," had already felt the grace of God and wanted to show his respect for this innocent man.

A large crowd of curious spectators followed the procession to Golgotha, which means "The Place of the Skull."

By no means did the soldiers put Jesus to death on the cross. The sinless, perfect God-Man could not be killed by sinful, imperfect men. He had laid claim to this when He said, *"No one takes [My life] from Me, but I lay it down of My own accord. I have authority to lay it down and authority to take it up again. This command I received from My Father."* Jesus used the cross as an altar upon which He sacrificed Himself.

MATTHEW 27:31–33; MARK 15:20–22; LUKE 23:26–33; JOHN 10:18

John and Mary at the Cross

Standing by the cross of Jesus were John; Jesus' mother; His mother's sister Mary, the wife of Cleopas; and Mary Magdalene.

When Jesus saw His mother and John standing there, He said to His mother, *"Dear woman, here is your son."* And to John, the disciple whom He loved, He said, *"Here is your mother."*

And from that hour John took Mary into his own home.

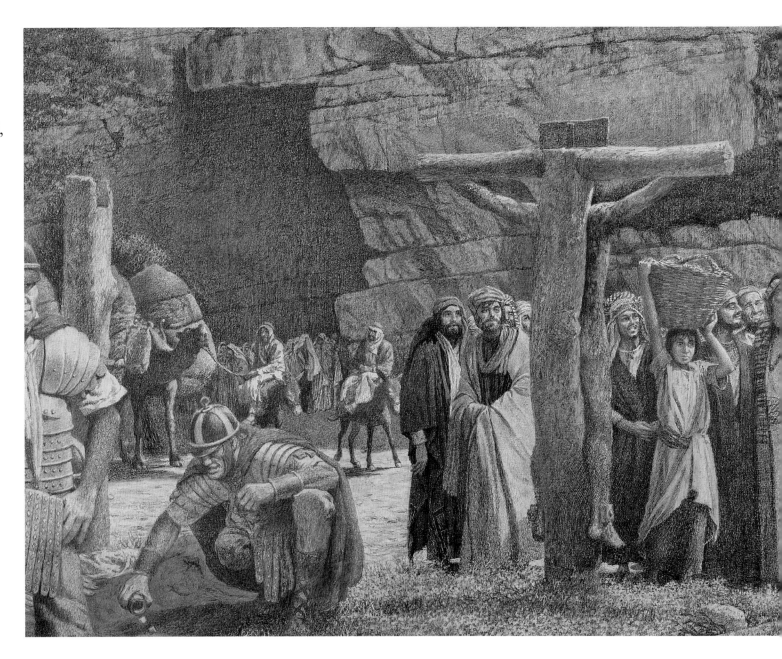

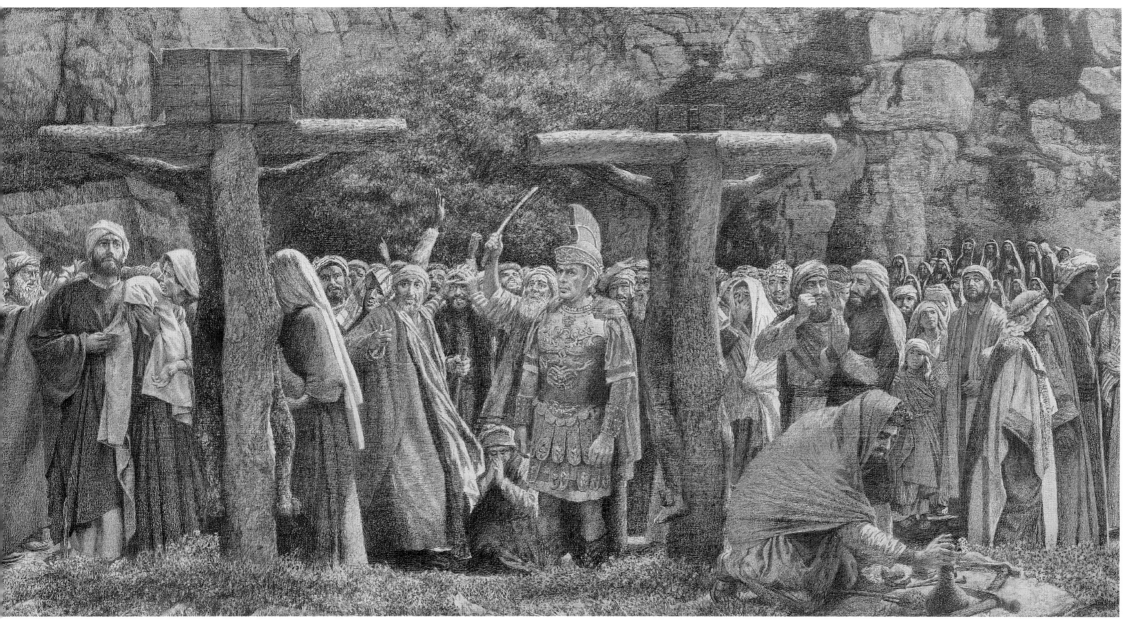

John 19:25–27

For that short, infinite interval
 when darkness covered the scene,
 God the Father departed from Jesus for the
 only time in eternity.
There—in the agony of that separation—
 Jesus became the Great Redeemer
 for friend and foe alike.
Then He cried with a loud voice,
 "My God, My God, why have You forsaken Me?"

As we consider the anguish of the Son, let us remember that the Holy Spirit and our Heavenly Father, Who *"so loved the world"* as well, suffered together with Jesus in this agonizing sacrifice of atonement.

MATTHEW 27:45–46; MARK 15:33–34; LUKE 23:44–46; JOHN 3:16

Taking the Body from the Cross

Having removed Christ's body from the cross, Joseph wrapped it in a clean linen cloth. Then the servants took it and started for the tomb while the soldiers watched and His forlorn friends stood in mournful silence. But in heaven and on earth, the angels shouted for joy as this dead body disarmed the evil powers and authorities, making a public spectacle of them and triumphing over them by the cross.

In this scene Joseph of Arimathea and Nicodemus have started up the path which leads through the garden gate to the tomb. There they would wait to receive and prepare the body for burial.

Their hopes had died with Jesus. Still, they wanted the world to know that they were His friends.

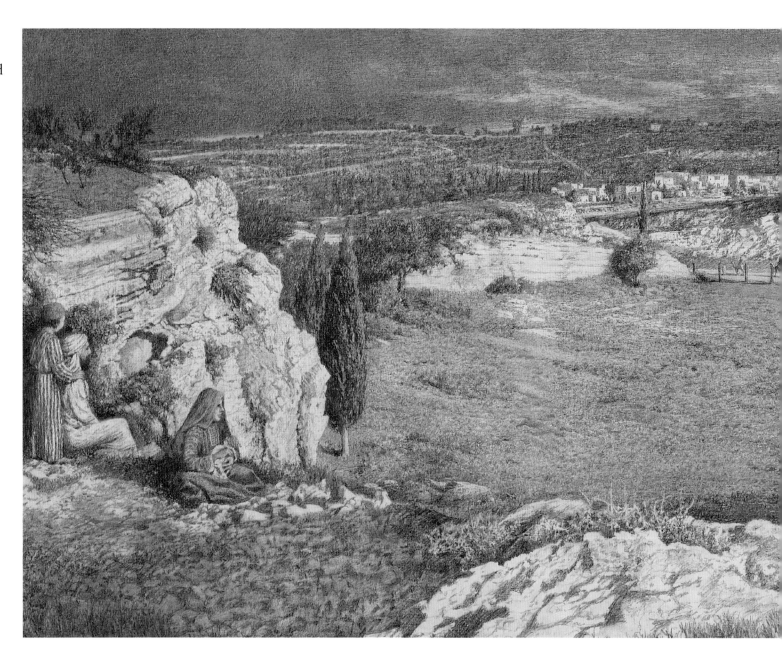

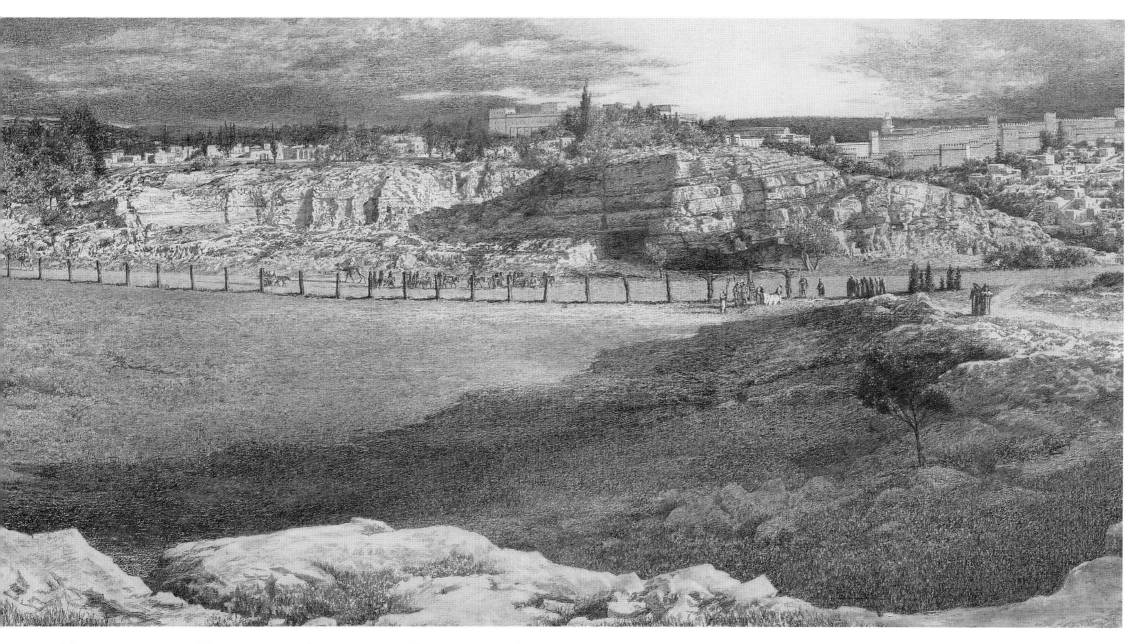

Matthew 27:57–59; Mark 15:42–45; Luke 23:50–52; John 19:38–40; Deuteronomy 21:22,23

Carrying the Body to the Tomb

While Joseph of Arimathea and Nicodemus wait at the tomb, the servants bring the body of Jesus. Behind them follow John with his new mother and the other women who had followed Jesus from Galilee.

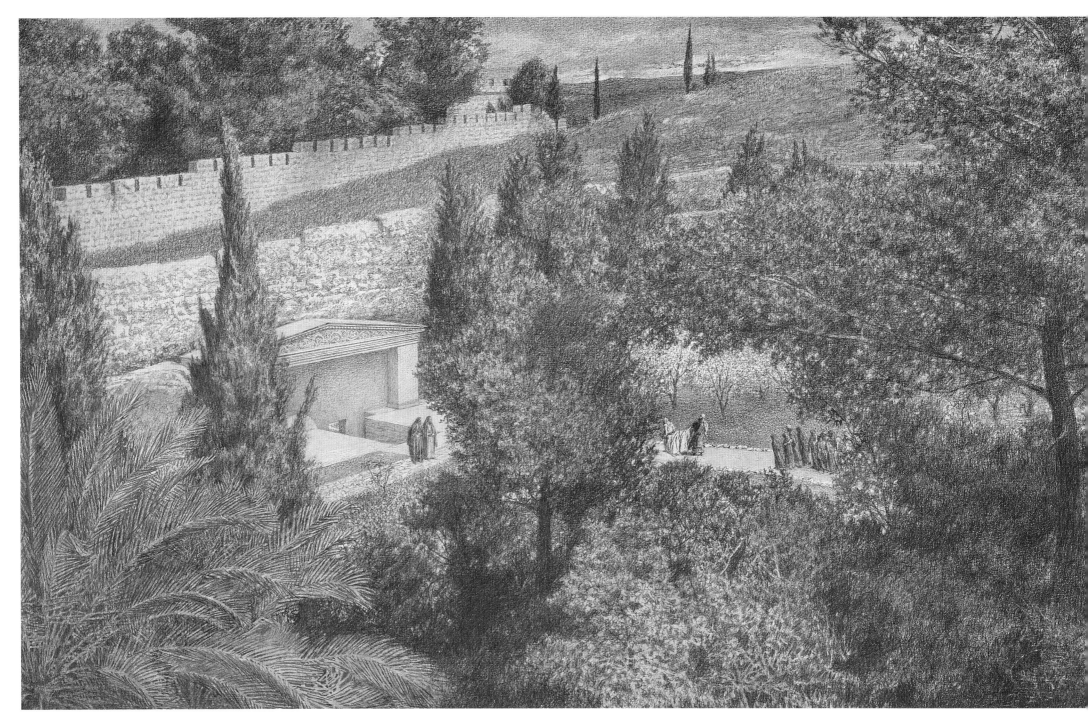

Never before had heartache been so deep.
Never before had anyone lost so dear a friend.

MATTHEW 27:60–61; MARK 15:46–47; LUKE 23:53–55; JOHN 19:41–42

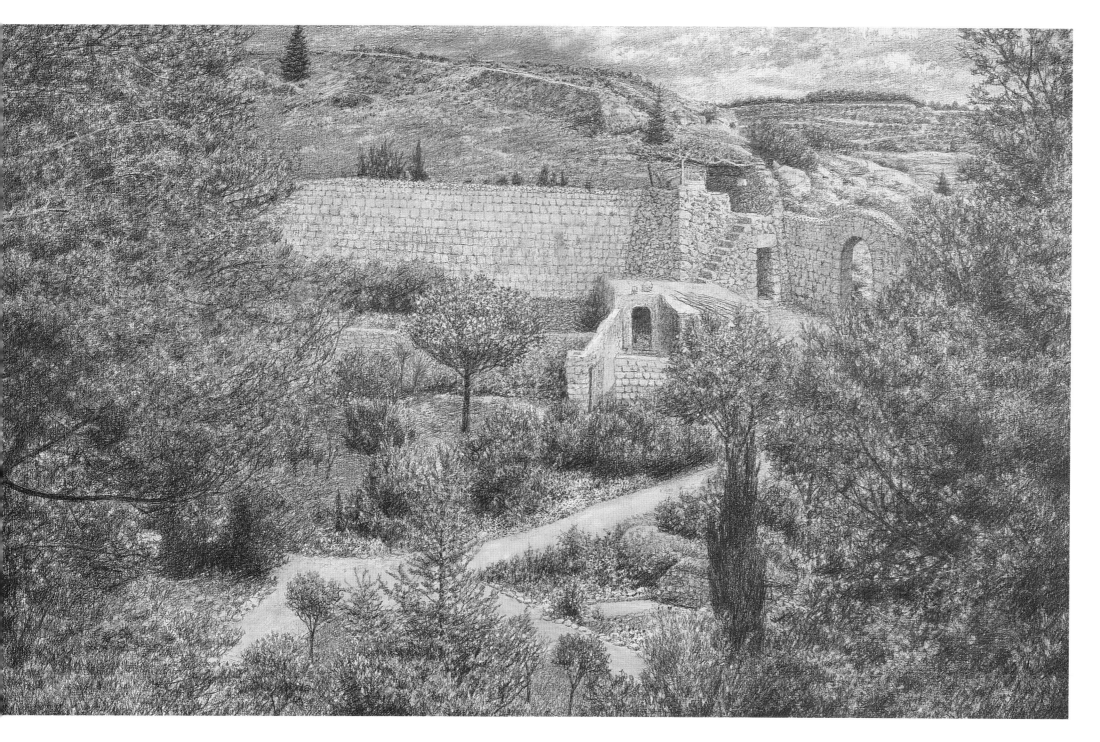

"Mary!"

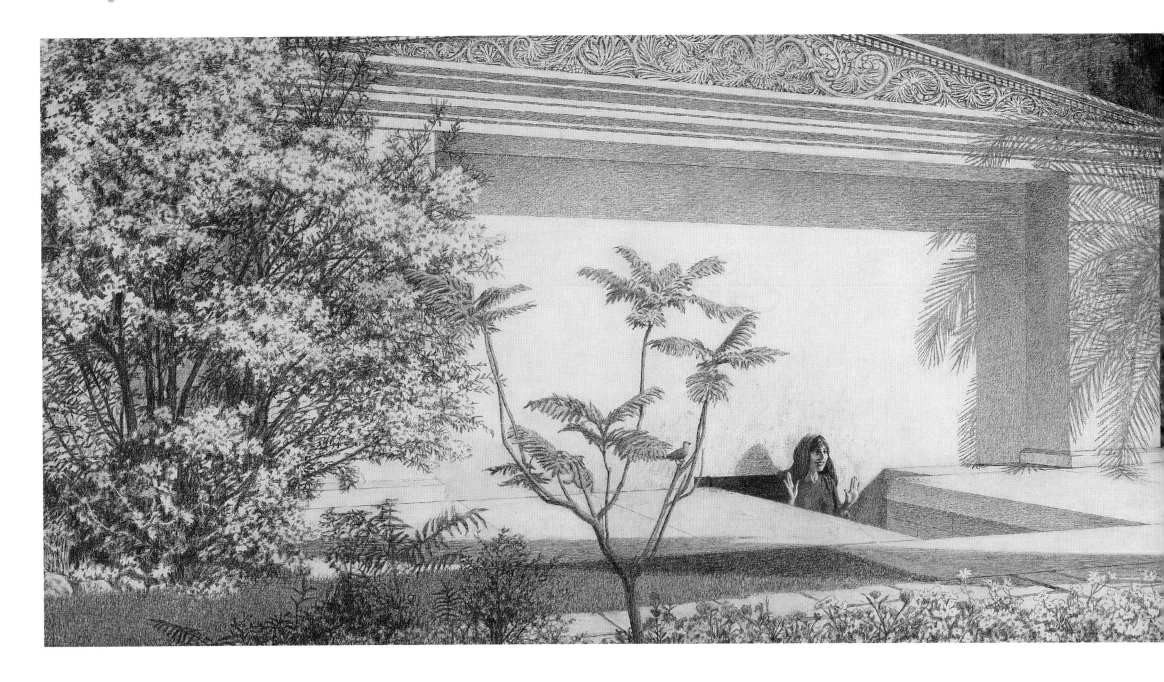

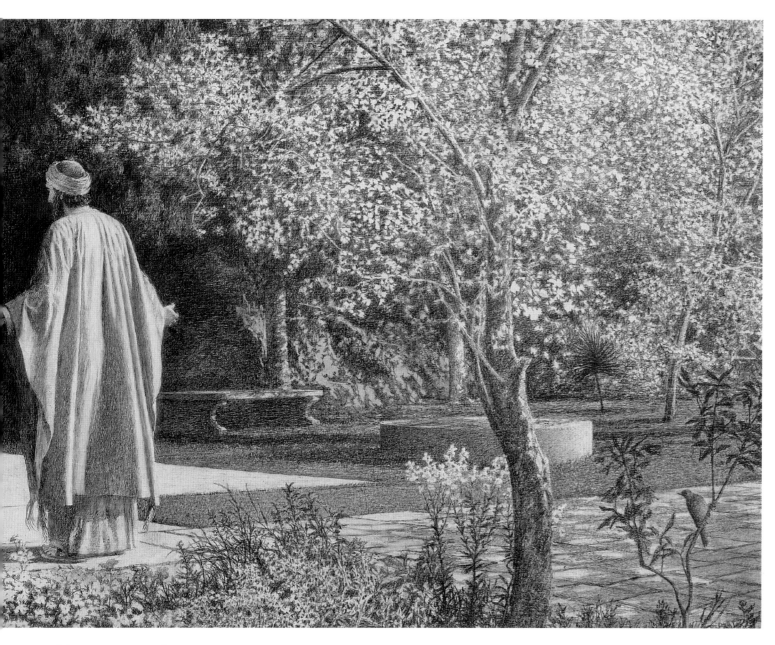

Note the position of the two-ton round stone (to the right, in the grass) that had been rolled into place to cover the entrance to the tomb. Luke writes of the stone as being removed a distance from the tomb, and so the angel removed it in such a manner to show that the power of God had put it there.

Mary was the first to arrive at the tomb before sunrise. It was empty! She found Peter and John and told them, and they went together and looked for themselves.

The body of Jesus was gone! They left the tomb, but Mary stood outside weeping. In her deepest grief, her spirit had died with Him. This was where she had last seen her beloved Lord, so this was where she would stay.

When she stooped to look in once again, two angels were there. She said, *"They have taken my Lord away, and I don't know where they have put Him."* They did not answer, for Jesus would answer for Himself. Mary, turning around, saw through her tear-dimmed eyes a figure standing nearby. Thinking Him to be the gardener, she said, "Sir, if you have carried Him off, tell me where you have taken His body, and I will take care of it."

"Mary," He said.

And she lived again!

MARK 16:1–10; JOHN 20:1–16

On the Road to Emmaus

The gloom hung heavy over the two disciples as they went on their way from Jerusalem. Jesus joined them as they neared Emmaus; and as He walked with them, He explained from the Scriptures how the Messiah had to die to save His people from their sins and then rise from the dead to confirm it. As He showed them this, their hearts began to rally with hopeful expectation.

So it is in the sky. The bright clouds appear on the horizon and lift the dark clouds until they finally disappear. Then a bright cloud bank takes possession of the sky over the house where Jesus revealed Himself to them before vanishing out of their sight.

They probably finished their supper on the way back to Jerusalem, so eager were they to share the world-shaking news!

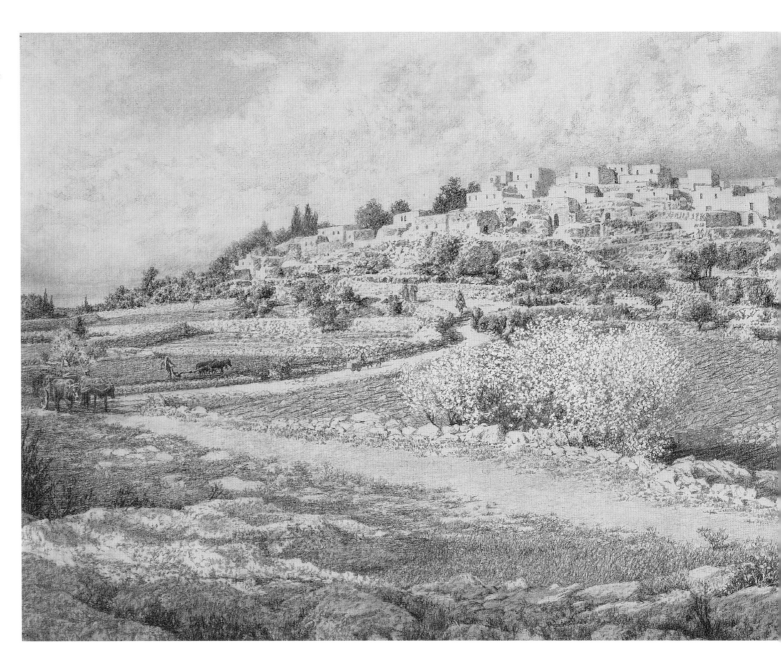

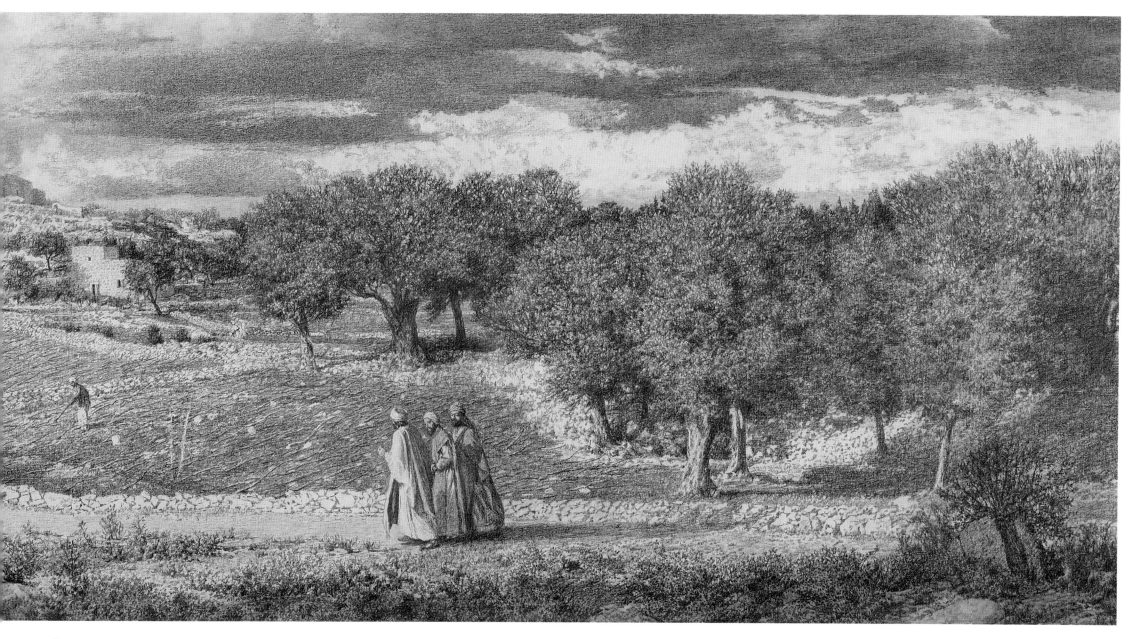

Luke 24:13–32

Thomas Believes

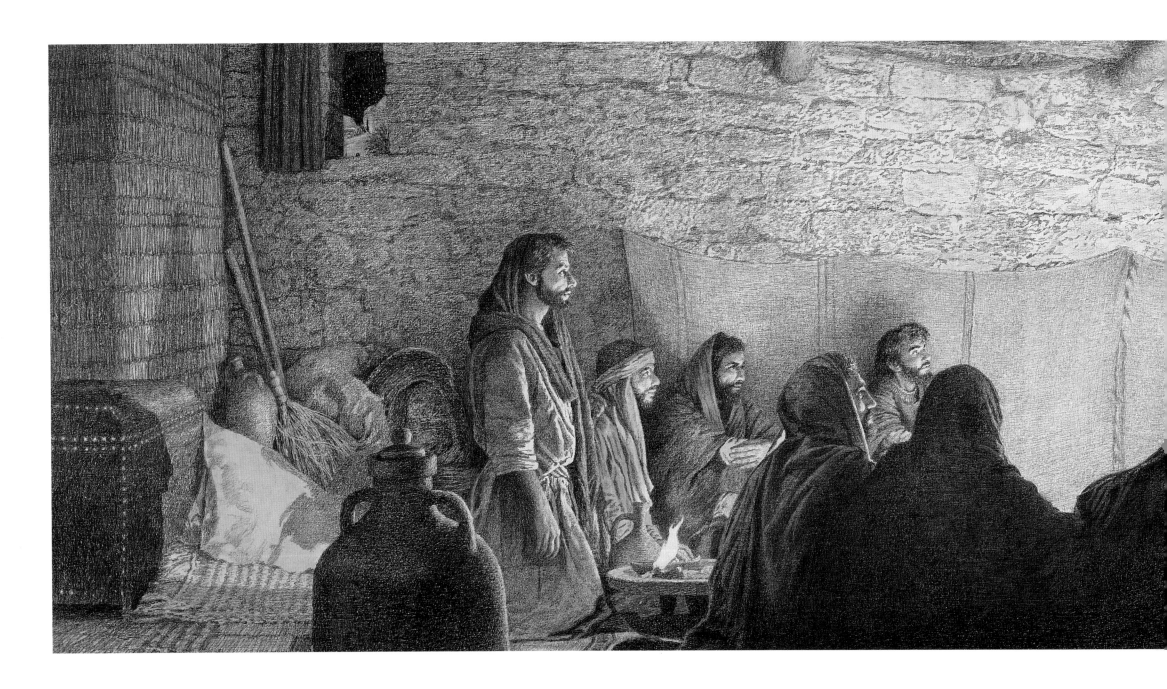

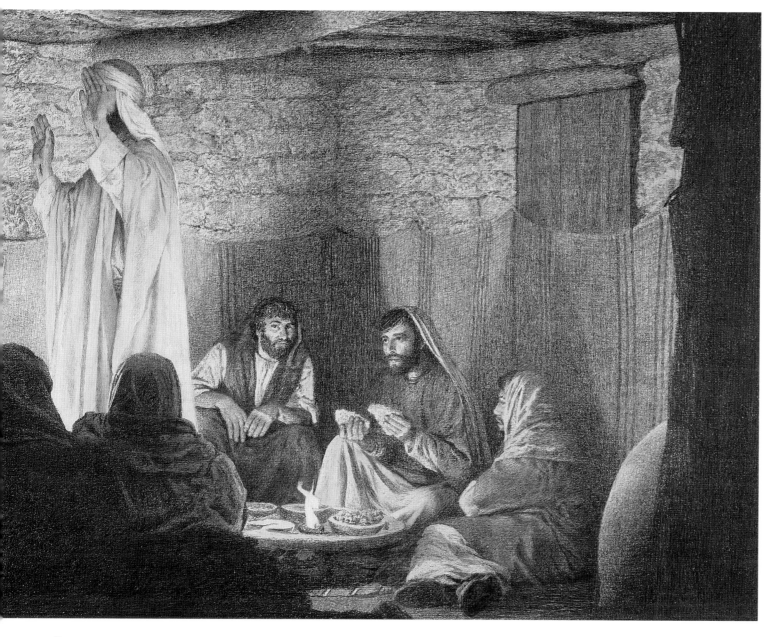

Eight days after Jesus first appeared to all the disciples (except Thomas), the disciples gathered in a room, and this time Thomas was with them. He had vowed that he would not believe until he could touch Jesus. Though the doors were shut, Jesus appeared, and stood in their midst and said, "Shalom." Then he said, "Thomas, reach out your finger and touch My hands, and put your hand into My side so you can believe."

Thomas cried out, *"My Lord and my God!"*

Jesus said, *"Because you have seen Me, you have believed; blessed are those who have not seen and yet have believed."*

JOHN 20:25–29

The Miraculous Catch of Fish

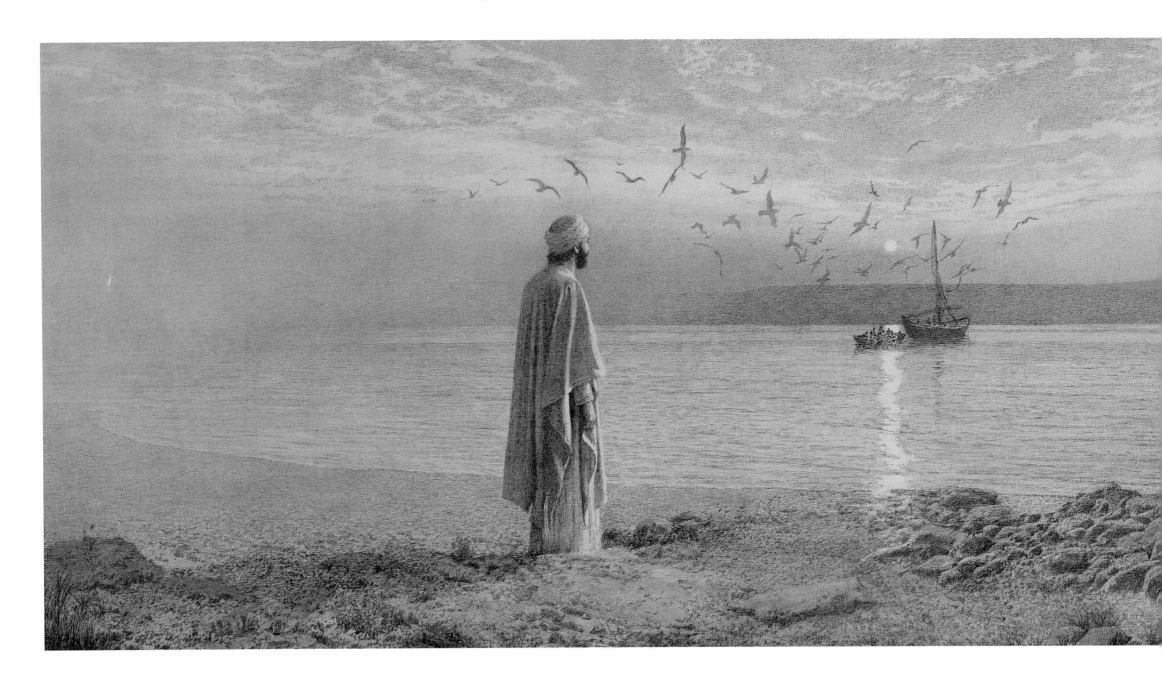

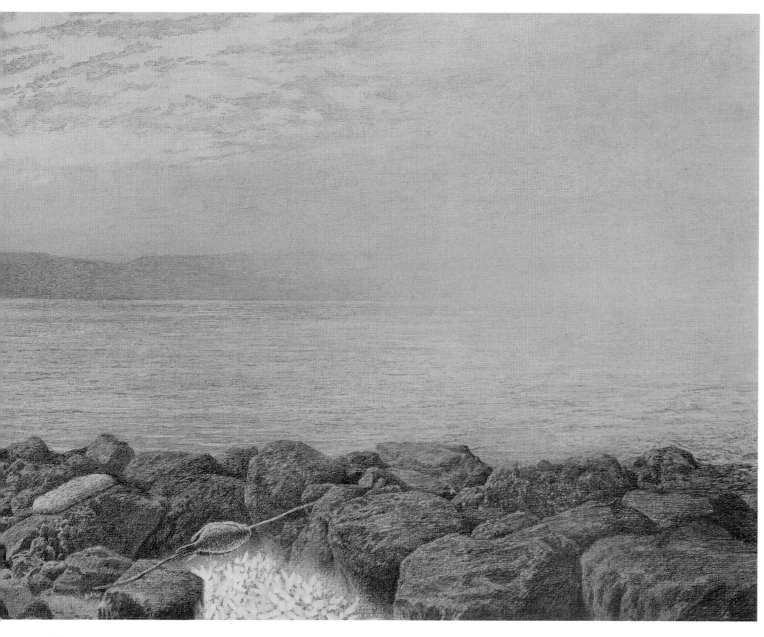

The disciples fished all night without success, but when Jesus called to them in the morning to put their net on the right side of the boat, the net was so full they couldn't pull it into the boat.

Jesus was showing them once again that He would always have the answer to their every need, even in places that seem completely empty.

Jesus had prepared breakfast for the disciples as well with a small fish and a loaf of bread. Would that be enough for seven hungry fishermen?

It would if Jesus had lovingly planned another miracle. Just as He had fed multitudes with a few loaves and fishes, He was about to feed these disciples with one small fish and one loaf.

What a precious way to start the day!

JOHN 21:1–13

The Great Commission

The eleven disciples went into Galilee to the mountain where Jesus had appointed them. This could be Mt. Hattin. Here He had appointed them for the ministry to the people of Israel. Now He was appointing them to minister to the rest of the world.

Then Jesus came to them and said,
"All authority in heaven and on earth
has been given to Me.
Therefore go and make disciples of all nations,
baptizing them
in the name of the Father
and of the Son
and of the Holy Spirit,
and teaching them to obey everything
I have commanded you.
And surely I am with you always,
to the very end of the age."

On the right a haze is settling over Galilee where most of our Lord's ministry took place. On the left, in the northwest direction where eventually the gospel would spread and prosper, the sky clears. And in the far distance, a lofty cloud represents the glory of the gospel being clearly seen in all its majesty by the nations of the future.

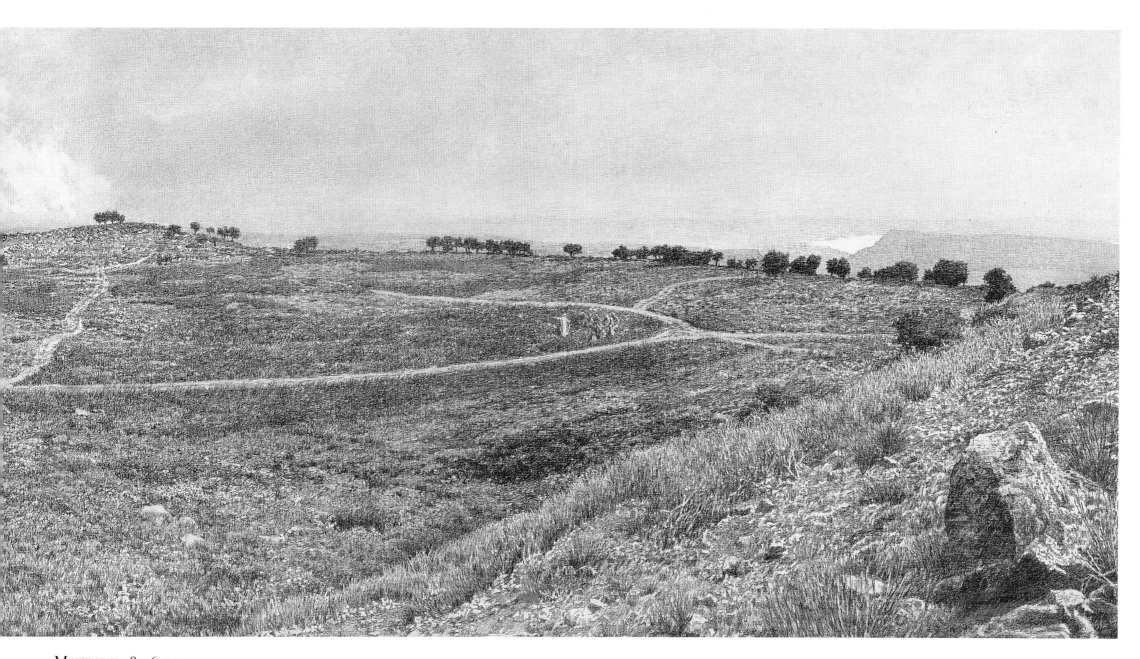

Matthew 28:16–20

The Ascension

In His final appearance to the disciples after His Resurrection, Jesus walked with them as far as toward Bethany (which can be vaguely seen on the distant hilltop on the far right). The site of His Ascension would seem to be just a stone's throw past the eastern slope of the Mount of Olives. In the further distance are the hills of the Judean desert on this side of the Dead Sea, and beyond them, the mountains of Moab on the far side of the Dead Sea.

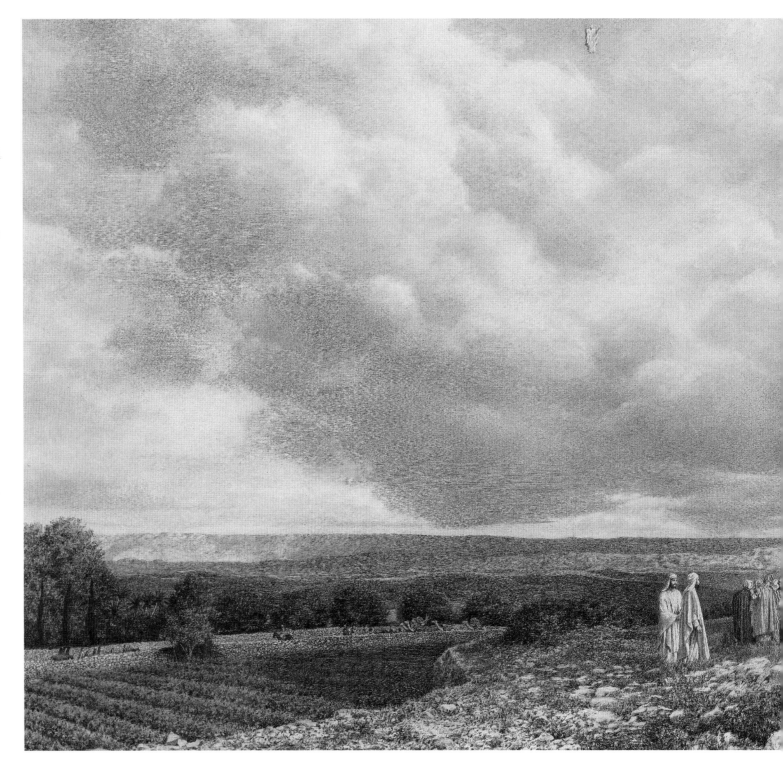

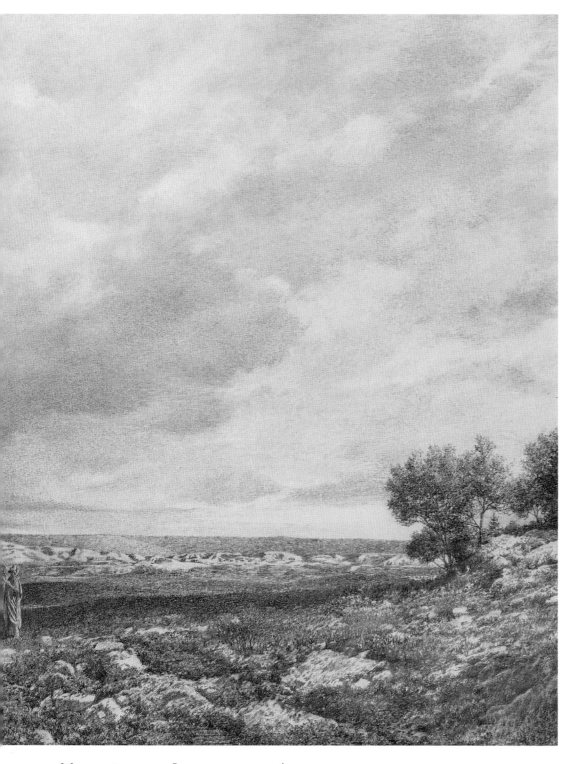

Jesus blessed the disciples and then ascended into heaven. While they watched, two men clothed in white stood by them and said, "Men of Galilee, just as you have seen Jesus received up from you into heaven, He shall return in like manner."

"Then they [the disciples] worshiped him and returned to Jerusalem with great joy. And they stayed continually at the Temple, praising God."

"Then the disciples went out and preached everywhere, and the Lord worked with them and confirmed His word by the signs that accompanied it."

ALL HAIL THE POWER OF JESUS NAME!

MARK 16:19–20; LUKE 24:50–53; ACTS 1:9–11

Artistry on Paper: The Making of Immanuel

You have just viewed one of the most magnificent and striking collections of art ever created on the life of Christ. You've read artist Robert Doares's story in the front of this book, and the amazing account of how the *Immanuel* drawings came to be. But as is usually the case with a project of this magnitude, there is also a story within the story—in this instance, the details of how such a *book* came to be. And as with the drawings themselves, this story is worth telling.

How does a book publisher, accustomed to capturing words on paper, go about capturing such artistry on paper? How do you translate the immediacy and impact of an entire art exhibit into book form without losing something in the process?

The search for answers to these questions began a full eighteen months before *Immanuel* appeared in print. The challenge was to discover if there was any way to reproduce the original 48" x 15" drawings in a smaller format without compromising their detail or depth. It did not take long for the Crossway Books staff to learn that none of the "standard" means of producing a book would work for *Immanuel*. The project was just too unique. From the size and format, to the binding and paper, to film processing and printing—everything would have to be specially researched and selected to ensure that the book itself would mirror the quality of the art collection from which it was taken.

The first hurdle to overcome was determining whether or not it was even possible to develop the filmwork needed to reproduce the art in printed form. Crossway contacted Computer Color Graphics (CCG) in Hillside, Illinois, to begin their search for answers. As specialists in high-quality filmwork for the printing industry, with clients such as Discover Card, Kodak, Spiegel, Zenith, and Florsheim Shoes, CCG provided the expertise and experience needed if *Immanuel, God With Us* was to be.

Because of the illustrations' unusual size and the fact that they were done on masonite, it was impossible for CCG to scan the art directly into their computer system. With that option eliminated, CCG explored a number of other ideas which they were confident would produce the desired results. However, test after test failed to yield the quality of reproduction necessary to take the project to the next step.

Soon the options for reproducing the art were almost exhausted. It was then that Noble Productions, a photography studio that had been contacted earlier, came up with an idea: photograph the artwork as black-and-white transparencies and then scan the transparencies into CCG's computerized system to create the needed filmwork. Although black-and-white prints had been tried earlier, transparencies had not, so CCG went ahead with this test. The transparencies maintained the integrity of the illustrations in all aspects and the film produced from them held excellent detail. Success! At that point, CCG was able to confirm that the filmwork needed to print *Immanuel* could be produced at the quality level Crossway desired.

CCG then began to fine-tune the process. Color proofs were produced from film and compared to the original artwork under a variety of lighting conditions. Careful adjustments were then made to guarantee faithful reproduction.

The next step was to choose a paper on which to print *Immanuel*. The paper which would be used had to fulfill four requirements: it had to be a durable enough sheet so the book would stand up to wear and tear; it had to be acid-free so that the pages would not deteriorate and yellow over time; it had to be opaque so that there would be no ink show-through from one page to another; and it had to allow for excellent printing reproduction. With the help of various industry professionals, the Crossway Books staff decided that 80-pound Karma Matte text—produced in Brainerd, Minnesota, by Potlatch—was the best paper for the project.

Once this decision was made, it was time to find a printer and a bookbinder to carry out the final production work on *Immanuel*. Crossway Books discussed the project with a number of companies, and even considered using a foreign printing firm. After months of investigation, Crossway finally chose Printing Arts Lithotech in Cicero, Illinois, for the printing and folding of *Immanuel*.

From the start great care was taken to ensure that the print reproduction of the book would be superior. Staff members from both Printing Arts Lithotech and Crossway Books met at the Billy Graham Center Museum at Wheaton College in Wheaton, Illinois, to view the entire *Immanuel* exhibit and discuss the obstacles that would need to be overcome in order to reproduce the art collection on paper at the highest quality level possible. After careful review it was decided that press proofing would be helpful in selecting the best color combinations for the printing and to finalize the film specifications. After that meeting, the staff at Printing Arts Lithotech worked in conjunction with the staff at CCG to prepare for the press proofing. Finally, the tests were run and final technical specifications for printing were made.

Meanwhile, the search was underway to find a bindery that could handle the unique size and format of *Immanuel.* Thorough investigation revealed that only three binderies in the United States were equipped to do so. R & R Bindery, located in Girard, Illinois, was one of these, and they were ultimately chosen as the supplier for this job.

To ensure the finest quality binding for this book, representatives from both Crossway Books and Printing Arts Lithotech visited R & R Bindery to discuss the printing, folding, and binding specifications. The unique and intricate details of such a book were worked out and finalized, and *Immanuel, God With Us* was on its way.

With the production questions answered, graphic design, layout, art production, and typesetting on the book could proceed. In consultation with Robert Doares, the interior design of *Immanuel* was finalized, including the sizing and placement of the illustrations.

The book you hold in your hands is the result of months of research and decision-making, old-fashioned hard work, and the expertise and experience of numerous publishing professionals. Professionals whose dedication to this project made *Immanuel* possible. Special thanks goes to:

Wayne Hultmark, Jan Jarolimek, and Eugene Lambeth of Computer Color Graphics; Bill Chmura, Ed Miglio, Susan Poznan, Tom Chaderjian, and Ken Wolgemuth of Printing Arts Lithotech; Kim Gerber of R.R. Donnelley & Sons; and Rick Roberts and Allan McIntire of R & R Bindery.

For everyone involved, this project has been a tremendous challenge—one that had no easy answers. It has also been a wonderful, once-in-a-lifetime privilege—one that made all the effort worthwhile. Above all, and throughout the entire process, one prayer has undergirded *Immanuel,* from artist Robert Doares on down: that this book would bring glory to God and remind every reader of its very personal truth—that we have a Savior who gave up heaven and became "God with us," all because He loved us.

Colophon

PHOTOGRAPHY
The art collection was photographed by Noble Productions of Bensenville, Illinois. The art was photographed as black-and-white transparencies on Kodak 6122 ETN film with a wooden Dierdorf 1114 view camera in diffused white light to minimize reflections. Exposures varied between F/16 and F/22, depending on the tonal range of the art.

FILMWORK
Film separations for *Immanuel* were made from black-and-white transparencies by Computer Color Graphics (CCG) of Hillside, Illinois. The transparencies were scanned into CCG's computerized system using a Crossfield high-resolution drum scanner to create duotones. Film was done at 175-line screen settings and was assembled on a Scitex imager using Agfa Gevascan S712 film.

TYPESETTING, EDITING, DESIGN
Immanuel, God With Us was designed and typeset by the Creative Services Department of Crossway Books, Wheaton, Illinois. The body text was set in 11-point Sabon by compositors Raymond J. Elliott and Jennifer Kok. The manuscript editors were Lane T. Dennis, Leonard G. Goss, and Kris Bearss. Brian Ondracek served as the creative director, and Mark Schramm was the graphic designer.

BOOK PRINTING
The printing of *Immanuel* was done by Printing Arts Lithotech of Cicero, Illinois, on a 28" x 40" OMCSA 6-color press. The pencil drawings were printed as duotones in black and PMS 410 (gray) inks; the six paintings, in four-color process inks on an 80-pound Karma Matte text stock. Folding of the book was done at Frank's Bindery of Chicago, Illinois.

JACKET PRINTING
The dust jacket was printed by Printing Arts Lithotech in black and two gray inks—a warm gray (PMS 410) and a pearlized gray (special mix)—on 100-pound Sterling gloss stock. The embossing of the cover was done at Creative Label in Elk Grove Village, Illinois.

BINDING
The folded signatures were sent to R & R Bindery in Girard, Illinois, for bookbinding. The signatures were Smyth-sewn on a National sewing machine. Most of the binding was done by hand because of the large size (13¼" x 9⅜") of the pages. The case material for the book is a Kivar 9 with a Firenza finish wrapped around a .098 binder's board.